Berlitz Publishing Company, Inc. Princeton Mexico City Dublin Eschborn Singapore

Copyright © 1999 Berlitz Publishing Company, Inc. 400 Alexander Park, Princeton, NJ, 08540 USA 9-13 Grosvenor St., London, W1X 9FB UK

All rights reserved. No part of this book may be reproduced or transmitted in any form or by any means, electronic or mechanical, including photocopying, recording or by any information storage or retrieval system without permission in writing from the publisher.

Berlitz Trademark Reg. U.S. Patent Office and other countries Marca Registrada

Text:	revised by Anna E. Williams and Nedjalka
	Markov Lambert; original text by Ken Bernstein
Editor:	Media Content Marketing, Inc.
Photography:	Daniel Vittet, pages 3, 4, 8, 9, 23, 25, 28-29, 34-35,
015	38, 41, 44, 51, 54, 57, 58, 60, 66, 70, 72-73, 75, 77,
	82-83, 86, 92, 94, 98-99, 143, 144, 149; Swiss Na-
	tional Tourist Board, pages 19, 20, 31, 33, 47, 78,
	116, 151, 156; and Claude Huber, pages 12-13, 18,
	47, 103, 106, 111, 115, 118-119, 123, 126, 137, 148.
Cover Photo:	Daniel Vittet
Photo Editor:	Naomi Zinn
Translation:	Media Content Marketing, Inc.
Layout:	Media Content Marketing, Inc.
Cartography:	Ortelius Design

Although the publisher tries to insure the accuracy of all the information in this book, changes are inevitable and errors may result. The publisher cannot be responsible for any resulting loss, inconvenience, or injury. If you find an error in this guide, please let the editors know by writing to Berlitz Publishing Company, 400 Alexander Park, Princeton, NJ 08540-6306.

> ISBN 2-8315-7159-6 Revised 1999 – First Printing April 1999

> > Printed in Switzerland 019/904 REV

CONTENTS

Switzerland and the Swiss	7
A Brief History	14
Where to Go	26
Zurich	26
Northeast Switzerland	38
Northwest Switzerland	45
Bern and Vicinity	55
Bernese Oberland	66
Lucerne and Central Switzerland	73
The Grisons	86
The Ticino	93
The Valais	102
Vaud and Lake Geneva	110
Fribourg, Neuchâtel, and The Jura	118
Geneva	128

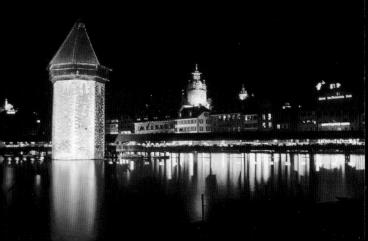

What to Do	141
Sports Festivals and Folklore Shopping Entertainment	141 147 147 151
Eating Out	152
Index	159
Handy Travel Tips	163

• A 🖝 in the text denotes a highly recommended sight

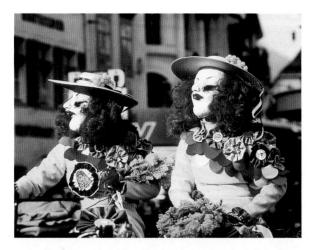

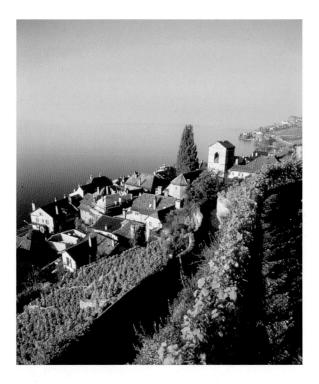

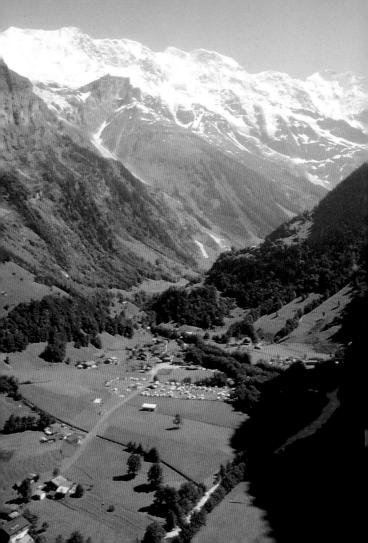

SWITZERLAND AND THE SWISS

A country of contrasts and of great natural and cultural resources, Switzerland is going through a period of important changes. On the eve of the third millennium, past and future coexist, confronting and completing each other in a present that may be less perfect than it was a few years ago, but which offers room for thought.

Here, forests of larch trees climb the mountainside of the Alps, dominated by peaks cloaked in eternal snows; fierce torrents hurl their icy waters into mirrored lakes; verdant valleys, sometimes scarcely wider than a ravine, resonate with the tinkling of heavy bells hung from the necks of plump and well-kept cows. Here and there, a castle gives the landscape a fairy-tale look. And everywhere, in the summer, geraniums cascade from windows and balconies.

No map can recreate the geographic reality of Switzerland. Nearly two-thirds of the country is mountainous. Some summits are more than 4,500 meters (14,760 feet) high; no one can resist the myth surrounding the Matterhorn (Mont Cervin) or the imposing trio formed by the Eiger, the Mönch, and the Jungfrau. To the east, beneath the slopes of the Grisons, lie the prestigious ski slopes of Arosa, Davos, and St. Moritz. Fertile lowlands, situated between the Alps to the southeast and the rocky green range of the Jura to the northeast, spread in a circle between Lake Geneva and Lake Constance. At once pastoral and industrialized, this narrow band contains all the big cities and the majority of the 7 million inhabitants that make up the Confederation.

The diversity of Switzerland, however, goes beyond its landscape and climate, which is glacial in the mountainous regions and nearly Mediterranean in southernmost Ticino. Cultural currents converge at this linguistic crossroads wedged between powerful neighbors. Three major languages have official status: in fact, some 65% of the populations speak *Schwyzerdütsch*, a German dialect, while 19% claim

7

A simple mountain life in living quarters such as these is the essence of the Swiss nation.

French as their major language, and 10% Italian. A fourth national language, Romansh (1%), spoken in some Grison mountain valleys, owes its survival to the fierce determination of its speakers.

Suisse, Schweiz, Svizzera, Svizra... the country has so many official names that its stamps and coins cannot contain them all. They bear its Latin name instead: *Helvetia*.

Each group has its own traditions, literature, gastronomy, and way of life, but there are cultural interchanges—some of them institutional, others more hidden, none of them easy— that make Switzerland a vibrant patchwork of individuals and ideas. Politically, a grass-roots democratic system takes account of regional aspirations. Each of the 26 cantons and demi-cantons which comprise Switzerland enjoys considerable autonomy, as do some 3,000 communes, rural and urban. Popular initiatives and referendums are used on the local and national level to propose new laws or to abolish contested regulations. All of these mechanisms make the political apparatus somewhat cumbersome, slowing the the decision-making process.

As Switzerland has chosen to have a grass-roots parliament, it has also chosen to have a grass-roots, militia-based army: all eligible men less than 42 years of age are enrolled in the army and required to do regular military service. For, strange as it seems, neutral, peaceable Switzerland is ready to respond to any attack: antitank traps, bunkers, and landing strips are hidden in the most bucolic valleys.

Executive power in Switzerland is entrusted to a cabinet of seven "wise men" elected by the Parliament, a system which respects the subtle balance of power among political parties, as well as among regions. Each of these seven in turn assumes the role of President of the Confederation. Since each President's term only lasts one year, the average citizen often has a hard time remembering who is in office.

The modesty that characterizes Switzerland's political figures extends to the population at large. The Swiss do not like to hear praise, either of their country's riches or of its position. If it is true that the average standard of living is high, one must remember that this prosperity has been acquired in spite of meager natural resources. Lacking coal and oil, the Swiss have struggled to tame the waters of their own Alps. Mineral resources are imported, then transformed into luxury goods which can be exported for profit.

The local Swiss people continue to uphold deep-rooted traditions as part of everyday life.

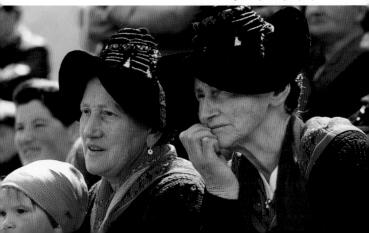

Of course, Swiss trains are more punctual than most; of course the sidewalks are cleaner and traffic laws more respected than in some neighboring countries. But if the concern for order and detail still characterizes Swiss life to an extent that may at times seem pedantic, there are also bursts of whimsy and exuberance, especially in cultural and artistic life. Two examples: the building projects for the 2001 exposition, and the Street and Lake parades organized in Zurich and Geneva. Also, because of the large numbers of foreigners in the country—political refugees, immigrant workers, or stars escaping the tax laws of their own countries—some neighborhoods, particularly in the big cities, are nothing like the Swiss clichés.

The German-speaking majority occupies most of the country, except for the West and Southwest. Zurich, the economic and financial capital of the country, is at the heart of this majority. In the realm of international finance, the "Zurich gnomes" have the reputation of being able to make judgments which can make or break a business, or more. But for tourists, the city offers elegant boutiques, museums, music, and memories of a rich past.

Geneva, the largest French-speaking city, has a very cosmopolitan air, thanks to its location at the French border and to the presence of dozens of international businesses and organizations.

The political capital of the Swiss confederation, Bern, is provincial and modest, lying halfway between these two linguistic poles and economic rivals. No grand monuments or majestic avenues here: Bern is too Swiss for such pomp. Nonetheless, it is one of the most agreeable capitals in Europe.

Each Swiss city has its own particular atmosphere, tied to its history, language, and vocation. Even the smaller cities have much to offer culturally. One morning in a car is enough to go from the covered bridges of Lucerne to the orange groves of Lugano, in the heart of the Italian region, but the spectacular change in language, culture, and climate is as great as the Alps which separate these two regions. Many Swiss villages deserve a stopover. Local arts and crafts, architecture

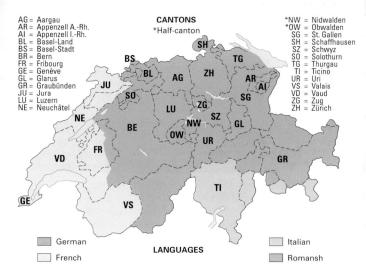

(some small towns boast remarkable medieval houses), local costumes —all offer something of interest, as does the landscape itself.

Unless you have made the trip just to visit museums and old country churches, you'll probably spend plenty of time outside, breathing the pure air of the mountains. Do you have energy to spare? Then scale the peaks or explore them on horseback; ski, wind-surf (year round), play tennis or golf; swim; go sailing, hang-gliding, waterskiing, or fishing. Take a stroll in the woods or the countryside, following the yellow arrows to foot-paths. (These arrows indicate not only what direction to go, but how long it will take to arrive at the next stop.) Take advantage of the many mountain-bike paths throughout the country.

And the shopping... Store windows tempt you with the most seductive luxury goods—watches, jewelry, and the latest fashions. Given the quality of Swiss workmanship, these buys are worth considering. If

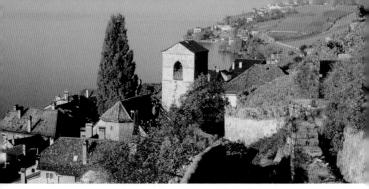

The tranquil village of St. Saphorin descends abruptly to the shores of the Lake of Geneva.

your budget is tight, do some window shopping. Take the time to stroll through the colorful stalls of an open-air market; they are held once or twice a week in nearly every city, and you'll find flowers, fruit and vegetables in season, sausages, country bread, and handmade objects.

Do partake of the pleasures of the table. In Switzerland you can eat well and with great variety, and there is something to suit every budget. The Geneva region, among others, is known for its extraordinary number of fine restaurants. And cheese is a favorite everywhere, in *raclettes* or in fondues. Some regions, such as Valais, Neuchâtel, or the Ticino, are known for their wine-growing traditions.

Lovers of nightlife will not be disappointed; even in Calvin's old town, Geneva, nightclub patrons revel far into the night. Zurich has a genuine redlight district. For simpler pleasures, have a seat in the first café you see and try the local wine, probably grown on a nearby hillside. No hurry: the locals spend hours there, before a *deci* (deci-liter, or one-tenth of a liter) or a *demi* (demi-liter, or one-half of a liter) of white wine, reading the Swiss papers.

When the time comes, it may be hard to leave this little world, at once orderly and magnificent. Behind its unforgettable postcard exterior lie facets as surprising as they are fascinating.

Famous Swiss Citizens

Mario Botta (1943): Born in the Ticino, he is one of the greatest contemporary architects.

Le Corbusier (1887–1965): This architect, painter, and creator of the Purist movement is one of the defining figures of the 20th century.

Henri Dunant (1828–1910): This Geneva humanist founded the Red Cross and later the CICR. He won the Nobel Peace Prize in 1901.

Friedrich Dürrenmatt (1921–1990): One of the greatest German-language dramatists of the 20th century.

Alberto Giacometti (1901–1966): Painter and sculptor of international renown.

Jean-Luc Godard (1930): Intellectual filmmaker; a worthy representative of the *auteur* theory of cinema.

Carl Gustav Jung (1875–1961): A famous disciple of Freud's who later opposed his master.

Paracelsus (1493–1541): Doctor, alchemist, and philosopher, he is considered one of the fathers of homeopathy.

Johann Heinrich Pestalozzi (1746–1827): Famous educator and advocate of Rousseau's ideas on education, he worked in the service of underprivileged children.

Jean Piaget (1896–1980): Psychologist known worldwide for his work on child development.

Charles-Ferdinand Ramuz (1878–1947): One of the best-known writers of French-speaking Switzerland.

Jean-Jacques Rousseau (1712–1778): Philosopher, statesman, writer—a major figure in the Enlightenment of the 18th century.

Jean Tinguely (1925–1991): Contemporary artist, specialist in "mad machines."

A BRIEF HISTORY

Thousands of years before William Tell, Switzerland was covered in glaciers. Its first known inhabitants lived in caves, eking out a living by hunting and gathering. When the glaciers receded some 5,000 years ago, the people were able to move to the banks of lakes and rivers, where they built villages on pilings.

During the Second Iron Age, somewhere around 400 B.C., a Celtic tribe known as the Helvetians, from whom Switzerland derives its original name, arrived in the region. In the year 58 B.C., this tribe, looking for new territory, burned their farms and encampments and emigrated to the Southwest. They are estimated to have numbered about 370,000 at that time. But the legions of Julius Caesar stopped them at Bibracte, pushed them back, and colonized their territory. The Romans established their administrative capital at Aventicum, nowadays a sleepy village (Avenches) between Lausanne and Bern.

The Romans built roads and also brought in their technical developments and culture, just as, later, they would be the vehicle of the new Christian religion. During the decline of the Roman Empire, the eastern half of the country fell into the hands of the Alemanni, a warlike Germanic tribe, while the western half wound up under the control of the Burgundians. The Sarine River, which marks the boundary between these two zones, remains to this day the linguistic and cultural frontier between German- and Frenchspeaking Switzerland.

The Middle Ages

Both the Burgundians and the Alemanni were soon succeeded by the Franks, one of the most powerful Germanic tribes. Under Charlemagne (768–814), the whole of what we now know as Switzerland was integrated into the Germanic Holy Roman Empire. From this epoch date the abbeys which were to become centers of study and culture. After the fall of the Carolingians (911) began a long period of political intrigue dominated by the powerful Zähringen and Hapsburg families. In the middle of the thirteenth century, two powers emerged: the house of Savoy and the house of Hapsburg. The inhabitants of central Switzerland opposed the extension of Hapsburg influence, leading them to swear to a mutual assistance pact linking three valley communities, the *Waldstätten*: Uri, Schwyz, and Unterwalden. This "pact of defensive alliance," agreed upon at the beginning of August 1291, is considered the foundation of the Swiss Confederation, an event commemorated on 1 August, Switzerland's national holiday. (From this epoch dates the legend of William Tell; see page 22.)

It was not until 1315 that the alliance took on its current meaning, when the Wäldstatten fought the Hapsburgs at the battle of Morgarten. The inhabitants of Schwyz fought so valiantly that the whole

Memories of medieval wars: here, a painting of Charles the Bold in flight.

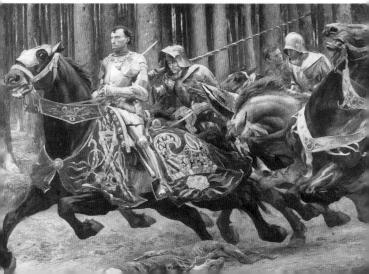

Confederation came to be called the "Swiss." During the fourteenth century, thanks to further alliances with other communities (Lucerne, Zurich, Glarus, Zug, and Bern), the Confederation grew to eight cantons, determined to fight foreign aggression.

The courage and prowess of the Swiss soldiers in the battles of Sempach (1386) and Näfels (1388), where they crushed the Hapsburgs, contributed to the forging of a solid Swiss military reputation. This reputation was confirmed in the Burgundian wars (Grandson and Murten in 1476, Nancy in 1477).

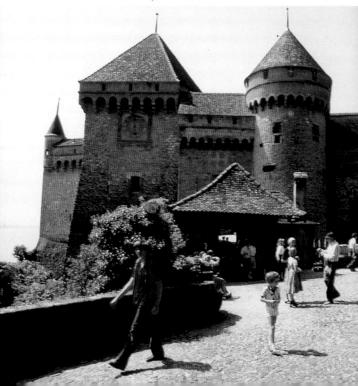

Turn of the Tide

Marignano, 1515. The first defeat of the Swiss army: more than 12,000 soldiers died in the battle. The Confederates nonetheless preserved their military reputation, henceforth serving as mercenaries to foreign armies. They no longer waged war on their own enemies, but rather on those of whoever paid them. The sight alone of these powerful halberdiers had a strong effect on their adversaries. It is their descendants who, today, stand guard at the Vati-

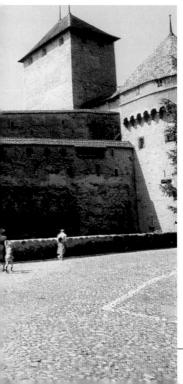

can in Renaissance costume (the only Swiss men of arms still serving abroad).

In 1516, the Confederation, which by then included 13 cantons (Fribourg, Solothurn, Basel, Schaffhausen, and Appenzell had by then joined the alliance), signed a perpetual peace treaty with France. Switzerland kept its territorial acquisitions (such as the Ticino), while France won the right to requisition its mercenaries at any time.

The continual tensions of the sixteenth century were exacerbated by the Reformation. In 1522, five years after Luther nailed his 95 theses to the Wittenberg church door in Ger-

The interior court of Château de Chillon, which has withstood countless battles.

many, Ulrich Zwingli, a priest from Glarus who had become the preacher at the main church in Zurich, also defied papal authority. In the years to follow, Zurich, Bern, Basel, and Schaffhausen would back the Reformation. But in the cantons of Uri, Schwyz, Unterwald, Lucerne, and Zug, as well as Solothurn and Fribourg, Catholicism remained firmly entrenched. Divided by religious fanaticism, the Confederation began to tear itself apart (the civil war of Kappel in 1531) before finally arriving at a compromise.

Through the mediation of the French reformer Guillaume Farel, Bern encouraged the propagation of the Reformation in Neuchâtel and Geneva, and took advantage of its success to spread its influence further. Under constant threat from the duke of Savoy, Geneva naturally called upon troops from Bern to defend itself. After chasing out the Savoyards, Bern occupied the canton of Vaud, where it worked to establish the new faith. But Geneva would not be dominated. In 1541, however, another French reformer, Jean Calvin, managed to establish a Protestant theocracy in Geneva. The "Protestant Rome" was born.

Lacking a centralized power and plagued by religious rivalries, the Confederates could not follow a coherent foreign policy. Since Marignano, they no longer participated in European conflicts except through the intermediary of their mercenaries. The Confederation embarked on the path of neutrality—an armed neutrality, born of the violation of Helvetian territory during the Thirty Years' War (1618–1648). Since 1647, this federal army, with Catholics and Protestants fighting side-by-side, watched over Swiss neutrality. Once peace was reestablished in the treaty of Westphalia (1648), the Confederation was considered a sovereign state, its independence universally recognized. The canton of Bern played the most significant role.

Beginning in 1685, the country became a land of asylum for many French Protestants fleeing their homeland after the revocation of the Edict of Nantes. But religious conflicts also raged in Switzerland throughout the 17th century. They broke out in 1656 (when victory went to the Catholics) and in 1712 (when victory went to the

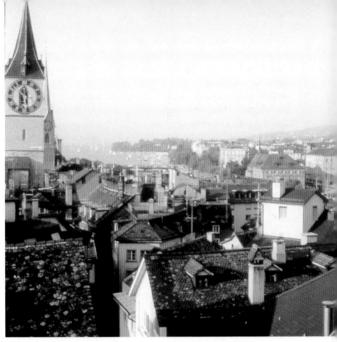

A walk through Old Town Zurich is a trip back through centuries of history.

Protestants) before ending in the Aarau peace agreement, which pronounced both regions equal. In the same period, social upheavals shook a Confederation where political rights still belonged only to the privileged. The profits of banking and commerce (in cotton, silk, wool, and clockwork) remained in the hands of these few.

It is not surprising, then, that the repercussions of the French Revolution of 1789 were strongly felt in Switzerland. After having occupied or annexed the portions of the Confederation they wanted

(in particular Basel, the canton of Vaud, the Valais, and Geneva), the revolutionary armies of France imposed the new "Helvetic Republic," whose artificial, centralized structures were anathema to most Swiss citizens.

Bonaparte put an end to three years of anarchy when he gave Switzerland a new constitution, the Act of Mediation (1803), inspired by the constitution of the ancient Confederation, and added six new cantons to the thirteen existing ones. He also took conscripts

Geneva's Palace of Nations is the European headquarters of the United Nations.

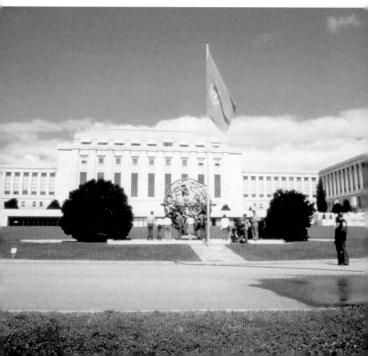

with him: 8,000 Swiss men died during the retreat of Napoleon's army from Russia.

Neutral, but Caring

The Congress of Vienna (1815) confirmed the independence and neutrality of Switzerland. Three new cantons (the Valais, Geneva, which had been occupied by the French from 1798 to 1813, and Neuchâtel, which remained simultaneously under allegiance to Prussia until 1857) had just entered into the Confederation, giving the country its current geographic shape. But the religious struggles between Catholics and Protestants were reignited. In 1847, the Catholic cantons separated from the Confederation (the Sonderbund alliance); however, a campaign ably led by General Dufour ended three weeks later in the dissolution of the pact and imposed the return to peace. Political stability and national unity were assured in 1848 by a new constitution which established a true Swiss democracy, with power shared equally among communal, canton, and federal authorities. The 1874 Constitution, still in effect today, has preserved these foundations.

Internationally, Switzerland has been recognized since 1863, when Henri Dunant founded the Red Cross in Geneva. Since then, the country has offered asylum to many important refugees, from Lenin to Solzhenitsyn.

The Society of Nations, which began in Geneva, has since become the European seat of the United Nations. Paradoxically, Switzerland chose to remain outside the United Nations, for fear of threatening its neutrality.

This neutrality was to be harshly tested by two world wars. The first spared Switzerland, but left it prey to a deep economic stagnation. As for the second, for fifty years the official version was that Switzerland had resisted entering the war thanks to its army and the will of its leaders and its people. In recent years, however, American investigators have uncovered the existence of Jewish

funds confiscated by the Nazis during the war and deposited in Swiss bank accounts. In the aftershock of this discovery, the Swiss people are painfully rewriting their history.

It seems evident today that this small country, despite the real and courageous mobilization of its army and its people, could never have stood apart from the atrocities of the war without making certain compromises with the Nazi regime. Encircled for four years by Axis powers, it was forced to maintain most of its commercial relations with

The William Tell Affair

In a country without kings, it is the people who make history. Whether he is based on a legend or a real person, William Tell nevertheless remains the Swiss national hero.

At the beginning of the 14th century, this simple peasant had the courage to stand up to a tyrannical governor. Having refused, in his passage through Altdorf, to salute the Bailiff Gessler, a representative of the Hapsburgs, William Tell was condemned by Gessler to shoot an apple off his son's head with an arrow.

Tell succeeded in one try; when asked why he had taken two arrows from his quiver, he explained that the second was for Gessler, in case he missed his shot. Furious, the governor ordered him thrown in prison. Then, as he was being taken by boat to the castle dungeon, a storm hit the lake, the Vierwaldstättersee. Only Tell was able to keep the boat from wrecking. He was untied. He brought the boat ashore at a place now called Tellsplatte, and there managed to escape. Later, he led an ambush against the tyrant near Küssnacht and killed him.

Schiller's play William Tell runs every summer to full houses in the open-air theatres of Interlaken and Altdorf.

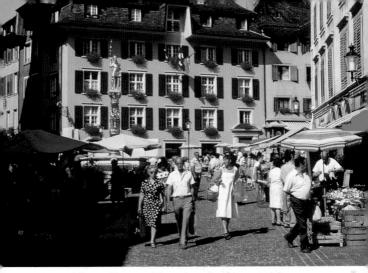

The weekly vegetable market takes over a patrician square in Solothurn.

those powers. In addition, the leaders of that time had to make a choice between the preservation of the country and a morally irreproachable neutrality. Today, a more realistic and human vision is emerging: weaknesses and strengths coexisted here, as they did everywhere.

The concept of neutrality, along with that of direct democracy, remains at the heart of Switzerland's concerns—not only for historical reasons, but also for economic and political ones, tied to the present and the future. Far from being settled, these concepts are the subject of intense debate. Switzerland's refusal to join the European Economic Community in a worldwide referendum in December 1992, and the strategic choices it has made for its future, shook the entire country, lending new dynamism to a political life which had long rocked in a lullaby torpor.

Historical Landmarks

The Origins of the Confederation

58 B.C.	The Helvetians attempt to invade Gaul and are pushed back by Julius Caesar; Romans begin to colonize Swiss territory.
A.D. 260	First invasion of the Alemanni.
6th century	Arrival of the Franks.
9th century	The territories comprising modern-day Switzerland are incorporated into the Holy Roman Empire.
11th-13th century	The powerful Hapsburg family acquires important territorial possessions in the area.
13th century	The "Alpine corridor," used as part of the pilgrimage route of Saint Gotthard, assumes a growing importance in Euro- pean commerce.
1291	The Pact of Rütli between the cantons of Uri, Schwyz, and Unterwalden is the founding act of the Helvetic Confederation.
1315	The Waldstätten crush Austrian troops at Morgarten; beginning of the military power of the Confederates.
1515	Defeat at the battle of Marignano; the end of Swiss military power and the first step toward neutrality.
1525	The beginning of the Reformation in Switzerland.
1536	Bern invades the Vaud country; the Con- federation spreads to the French-speak- ing regions.
1685	Revocation of the Edict of Nantes; many French Huguenots go into exile.

The Modern Period

1798	France (specifically, the Directoire Gov- ernment) imposes a Republican structure on Switzerland.
1803	Return to federalism; six new cantons join the Confederation.
1815	The Congress of Vienna consecrates the independence and neutrality of Switzerland.
1847	The war of Sonderbund.
1848	The birth of the modern Confederation; a central government is established in Bern; first constitution.
1863	Creation of the Red Cross in Geneva.
1914–1918 and 1934–1945	Switzerland maintains its neutrality and commitment to humanitarian causes.
1937	Labor unions renounce the right to strike; labor agreement reached.
1971	Women of Switzerland win the right to vote in federal elections.
1979	Division of the Jura through the secession of a French-speaking part; birth of a 23rd canton.
1992	In a national referendum, the Swiss refuse to join the European Economic Communi- ty, but do vote in favor of participating in the IMF and the World Bank. The govern- ment presents its candicacy to the EC.
1999	Ruth Dreifuss becomes the first woman to serve as President of the Confederation.

WHERE TO GO

Nothing could be easier than getting around Switzerland (see pages 168 and 181). The highway system is excellent, trains and buses service the most remote villages, and urban transportation is extremely efficient.

Below are some suggestions for trips within the country; obviously, this is a subjective list, but it does contain most of the important sites, and should help you to efficiently plan your itinerary.

Exploring more than one region a day is not impossible, but we don't recommend you visit Switzerland on a racer's pace. You will make your best discoveries off the beaten track. Don't forget, either, that places that look close together on the map may not be so in reality. You may be overlooking the mountain ranges and hairpin turns that lie between one spot and the next.

In this guide, the country has been divided into twelve regions that more or less correspond to those given by the Swiss tourist office.

ZURICH

Greater Zurich (with one million inhabitants), situated at the extreme north of the lake of the same name, is Switzerland's largest urban center.

Despite its economic importance, which places it on a footing equal with New York, London, or Paris, the atmosphere of this town remains very warm and human—earning it the nickname, the "Big Small Town."

Zurich (*Zürich*) has been a financial capital for little more than a century: its stock exchange was founded in 1877. But the history of the city goes back to time immemorial. Since the Neolithic period, men have built villages on pilings along the banks of the Lake of Zurich. Two thousand years ago, the Romans established a customs office, Turicum, on a hilltop overlooking the Limmat River. This spot, today known as the Lindenhof, constitutes the geographic cen-

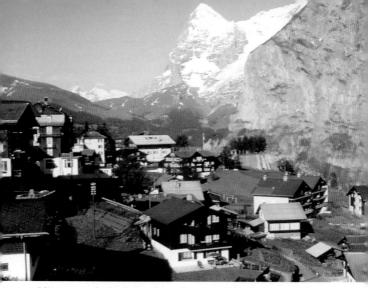

Mürren, reached only by cable railway or cable car, is nonetheless a popular excursion in all seasons.

ter of the city. It took another thousand years for Zurich to be recognized as a city, and then to gain fame as a prosperous industrial center specializing in silk-, wool-, and linen-weaving. In 1351, when Zurich joined the Confederation, its noblemen and merchants agreed to share their power with representatives from the tradesmen's guilds, whose guildhalls are still among the treasured monuments of the old town.

In the 16th century, Ulrich Zwingli brought the Reformation to Zurich, thus adding intellectual renown to the ever-growing commercial and political importance of the city. Through the centuries, Zurich has distinguished itself as a center of liberal ideas, attracting a number of great men, such as Goethe, Wagner,

Thomas Mann, Einstein, James Joyce, Lenin, and Trotsky (these last two spent innumerable hours together at Zurich's Café de l'Odéon). It was from Zurich that Lenin and his Bolshevik colleagues departed, in 1917, aboard the famous "sealed train" that crossed Germany to reach chaotic Saint Petersburg.

Zurich (2 days) Old town, museums Limmat and lake boat trips Northeast Region (3 days) Schaffhausen, Rhine Falls, Stein am Rhein Saint-Gall and Appenzell Northwest Region (3 days) Basel Solothurn Baden **Bern and Vicinity** (2 days) Old town, Bear Pit, museums Biel The Emmental **Bernese Oberland** (2 days)

Thun and lake Interlaken Grindelwald and Jungfraujoch Gstaad Central Switzerland

(2–3 days) Lucerne, Transportation Museum Lake Lucerne Mount Pilatus and Rigi The Grisons (4-5 days) Chur Vorderrheintal. Hinterrheintal Davos and Klosters Engadine and the National Park The Ticino (3 days) Bellinzona Locarno and Lake Maggiore Ascona Lugano and lake The Valais (3 days) Saint-Maurice Sion **Zermatt and Matterhorn** Saas-Fee Vaud and Lake Geneva (2-3 days) La Côte Lausanne Vaud Riviera, Montreux, Château of Chillon Fribourg, Neuchâtel, and the Jura (3 days) Fribourg Neuchâtel and lake Geneva (2 days)

Old town, museums

It was also in Zurich, at the Cabaret Voltaire on the Spiegelgasse, that the Dadaist art movement was born during World War I. Nowadays, the city can boast over fifty galleries that exhibit artwork of all kinds. The University of Zurich, Switzerland's largest, and the famous Federal Polytechnic, considered one of the best engineering schools in the world, set the intellectual tone for the city.

Discovering Zurich

The Limmat river symbolizes the division between the modern, commercial city and the old town with its narrow, charming streets.

The most elegant shopping street in Switzerland and one of the most prestigious in the world, the **Bahnhofstrasse** ($1\frac{1}{2}$ km/1 mile), connects the train station to the lakefront. Jewelry and watches, furs and haute couture, antiques and art objects: all of the most luxurious items can be found here. Shaded by linden trees, the street is reserved for pedestrians, making it ideal for window-shopping. Not far from the train station, one stunning building will catch your eye. It's the observatory tower, the **Urania**, with its bar — the highest in the city. The observatory has a telescope with a magnification factor of 600.

The venerable **Fraumünster** dominates the west bank of the Limmat. Since 853, when a convent was founded here, there has always been a church on this spot. The current edifice dates from the 13th century. It has a lovely Romanesque choir with modern stained-glass windows designed by Chagall.

Nearby stands the most beautiful Baroque building in Zurich, the **Zunfthaus zur Meisen guildhall**, which was built by the wine merchants' guild in 1757. Today it houses a collection of ceramics from the Swiss National Museum. On the Münsterhof, the **Zunfthaus zur Waag** is older still, dating from 1637. Once the seat of the linen weavers' and hatmakers' guilds, it is now a restaurant, as are many of the old guild houses.

Charming little streets lined with boutiques and antiques shops lead you to the **Sankt Peterskirche** (Saint Peter's Church), the oldest church in Zurich. Its 13th-century belltower houses one of the largest clocks in Europe, more than 9 m (29 ft) in diameter. The Baroque-style nave is decorated with pillars of pinkish-orange marble, delicate stucco, and crystal chandeliers dating from the 18th century.

If you are willing to take on the steep stairs leading to the **Lindenhof**, you can enjoy a beautiful view over the Limmat, with its flat-roofed pleasure boats and, in the background, the alwaysbusy Limmatquai. The fountain on this square was built in honor of the women of Zurich, who saved the city when it was besieged by the Hapsburgs in 1292. Parading in full battle dress, they

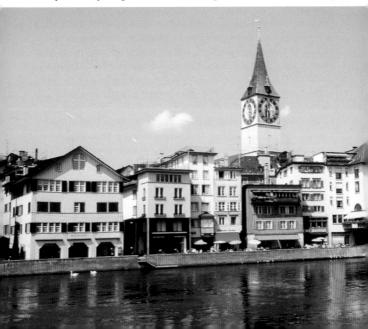

duped the enemy into believing that the city was too well defended to be conquered.

On the other side of the river, facing the Fraumünster, stands the the cathedral, **Grossmünster**, constructed between 1100 and 1250 on the site of a ninth-century church. The Grossmünster is the uncontested "mother church" of the Reformation in German-speaking Switzerland; it is here that Zwingli preached from 1519 until his death in 1531. The stained-glass windows, designed by Augusto Giacometti, are a modern-day addition. The twin towers, built in the 15th century and topped with domes from the 18th, have become the city's most distinctive landmark.

Windows by the same Giacometti brother also adorn the **Wasserkirche**, oddly situated astride the Limmat river.

On the east bank of the river stand the ancient guild houses, each more splendid than the last: the Zunfthaus zum Rüden, one-time gatheringplace of the nobility: the Zunfthaus zur Zimmerleuten the carpenter's guild built in 1708 and decorated with attractive oriel windows: and the Zunfthaus zur Saffran, headquarters of the haberdashers' guild. Opposite the latter is the Rathaus (Town Hall), a richly ornamented structure finished in 1698. Zurich's municipal and

The clock face on the tower of St. Peterskirche is one of the largest in Europe.

cantonal parliaments still meet here, as they have been doing since the building was completed.

After visiting the old town, take a stroll along the banks of the lake. The east side offers one surprising spot—the **Chinese Garden**, a gift to Zurich from its twin city of Kunming. Birds, flowers, fish, streams, and bridges: everything here has a flavor of the East.

Zurich's Museums

The **Kunsthaus** (Fine Arts Museum) contains collections of European painting from the Middle Ages to the 20th century. Swiss artists are particularly well represented. On view are works by Johann Heinrich Füssli (1742–1825), Arnold Böcklin and Ferdinand Hodler, both major figures of the 19th century, as well as the sculptor Alberto Giacometti. In addition to masterpieces by Monet, Cézanne, Van Gogh, and Picasso, the museum possesses the largest collection outside Scandinavia of works by the Norwegian artist Edvard Munch. An entire gallery is devoted to Chagall, while another has Dadaist works by Hans Arp, Francis Picabia, and Max Ernst. The museum owns collections from several important foundations, including the Alberto Giacometti Foundation, the Dada collection (with, most notably, the photographs of Man Ray), and the Swiss Photography Foundation. Temporary exhibitions of the highest quality are also shown here.

The Schweizerisches Landesmuseum, located in a curious Victorian-style edifice, celebrates the culture, art, and history of Switzerland. Its halls are bursting with Medieval sculpture and painting, and many rooms feature windows and frescoes that have been removed from ancient churches and houses and re-installed here. Upstairs, a huge room displays weapons, armor, military uniforms, and other military memorabilia. The museum has also reconstructed rooms from Swiss homes of several centuries ago.

Don't neglect the **Rietberg Museum**, tucked away in a luxurious and exotic park. The surroundings are in keeping with this museum's contents: traditional Chinese scroll paintings, Armenian carpets, Indian statues, Peruvian pottery, African masks, and the like, all of which were assembled by the Baron von der Heydt.

The **Kunsthalle** (Museum of Contemporary Art) invites contemplation of past and present in a 1,300 sq m (4,265 sq ft) exhibition space.

Along the lakefront, the **Zürichhorn** park has two wonderful attractions. The Heidi Weber house, **Le Corbusier**'s last work, is a refined mix of forms and colors. A little further along, you'll find *Heureka*—a fantasmagoric extraterrestrial bird, dreamed up by sculptor Jean Tinguely.

Excursions

If you want to discover an amazing **panoramic view** of Zurich, its lake, and the Alps, take the train to Üetliberg (871 m/2,860 ft) from the central train station or the Selnau station (15 minutes by foot from the Paradeplatz). The trip takes 25 minutes and there is a train every half-hour.

Modern as well as classical artists receive their due at the Kunsthaus (Fine Arts Museum) in Zurich.

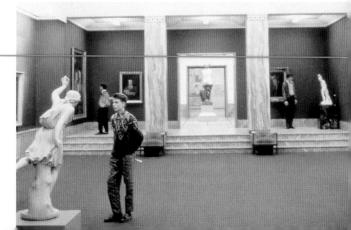

Major Sights—Zurich and Winterthur Zurich

Chinese Garden: Park Zürichhorn; Mon, Tue, Fri-Sun 11am-7pm, Thu 11am-10pm; 4FS

Jean Tinguely's Heureka: Park Zürichhorn

Le Corbusier Heidi Weber House: Park Zürichhorn; Sat–Sun 2–5pm (July–Sept); 10FS

Kunsthalle (Museum of Contemporary Art): Limmatstrasse 270; Tel. (01) 272-15-15; Tue-Fri 12-6pm, Sat-Sun 11am-5pm; 5FS.

Kunsthaus (Fine Arts Museum): Am Heinplatz 1; Tel. (01) 251-67-65; Tue–Fri 10am–9pm, Fri–Sun 10am–5pm; 5FS (permanent collections), 8–14FS (temporary exhibitions)

Museum für Gestaltung (Museum of Applied Arts): Ausstellungstrasse 60; Tel. (01) 446-22-11; Tue/Wed-Fri 10am-9pm, Sat-Sun 10am-5pm; 2–8FS, depending on exhibit

Museum Rietberg: Gablerstrasse 15; Tel. (01) 202-45-28/64; e-mail museum@rietb.stzh.ch; 3–12FS

Park-Villa Rieter: Gablerstrasse 15; Tel. (01) 202-45-28/64; Tue-Sat 1–5pm, Sun 10am–5pm

Haus zum Kiel: Hirschengraben 20; Tel. (01) 261-96-52; Tue-Sat 1-5pm, Sun 10am-5pm

Sweizerisches Landesmuseum (National Museum): Museumstrasse 2; Tel. (01) 218-65-11; Tue-Sun 10:30am-5pm; free

Zoologischer Garten: Zürichbergstrasses 221; Tel. (01) 252-71-00; Mon–Fri 8am–6pm (summer), 8am–5pm (winter); 5–12FS

Winterthur

Fotomuseum (Museum of Photography): Grüzenstrasse 44; Tel. (052) 233-60-86; Tue–Fri 12–6 pm, Sat–Sun 11am–5pm; 5–7FS Kunstmuseum (Fine Arts Museum): Museumstrasse 52; Tel. (052) 267-51-62; Tue 10am–8pm, Wed–Fri 10am–5pm; 5–10FS Museum Oskar Reinhart am Römerholz: Stadthausstrasse 6; Tel. (052) 267-51-72; Wed–Sun 10am–5pm (Tue 8pm); 7–10FS Technorama: Technoramastrasse 1; Tel. (052) 243-05-05; Tue–Sun 10am–5pm, open Mon during holidays; 8–14FS To explore Zurich by the Limmat river, take a lovely ride on one of the glass-topped boats that depart from the Landesmuseum every half-hour (from April to October) for a fifty-minute tour.

The Zürichsee is another sight best appreciated by boat. Cruises are available (either 1½ hours or 5 hours; lunch is provided) during which you can admire at your leisure the lovely small villages surrounded by orchards, vineyards, and appealing inns. The lakeside villages, especially those on the right

A visit to one of Zurich's restaurants is the perfect end to a day wandering its old-world streets.

bank (nicknamed the "Gold Coast") make up the wealthier suburbs of Zurich.

Most boats go as far as **Rapperswil**, a pretty medieval town standing in the shadow of a very well-preserved 14th-century château.

Other Points of Interest

At the height of summer (in August), Zurich plays host to thousands of techno music fans, of all ages and types, in the **Street Parade**. This celebration takes place in several venues, including Letzigrund Stadium, and consists of a series of exuberant and gigantic rave parties: a demonstration and a symbol of generosity, love, freedom, and tolerance.

For calmer sorts, there is the **Zürcher Theater Spektakel** at the end of the summer (August and September), when tents and stages are set up alongside the lake and elsewhere to welcome many wellknown theater groups.

As far as sporting events go, the **Golden League** athletic games, also held in August, are certainly worth a visit.

Lovers of swimming will rejoice in Zurich's lake. Visit the **Utoquai Baths**, dating from 1889 and built on the lake itself. The 19th-century baths on the Limmat, the **Badi am Stadthausquai**, are also inviting and reserved for women only. Likewise, there are allmale baths—the **Schantzengraben**—in the center of town.

Winterthur

Just fifteen minutes away from Zurich, this industrial city has no shortage of green spaces or artistic monuments, including several admirable buildings constructed between the 16th and 18th centuries. It is said that Winterthur is the city with the most works of art per capita in the world. It owes this preeminence to the generosity of wealthy art patrons like Oskar Reinhart, who left his col-

lection to the city upon his death in 1965.

Half of this collection is displayed in a massive 19thcentury building located in the middle of town. The **Oskar Reinhart Foundation** brings together some 500 choice works by Swiss, German, and Austrian artists of the 18th, 19th, and 20th centuries. Note in particular the rooms devoted to the German painter Caspar David Friedrich. And

The medieval town of Stein am Rhein boasts buildings with beautiful painted façades.

don't miss the portraits, landscapes, and narrative paintings of Ferdinand Hodler.

In the northern part of town, **Am Römerholz**, the villa where the benefactor lived, shelters the remainder of the collection. Museums from capitals around the globe would be proud to own the old master and French Impressionist paintings assembled here by Reinhart; from the elder Cranach and Brueghel to Cézanne and Van Gogh.

In town, not far from the Reinhart Foundation, the **Kunstmuseum** (Fine Arts Museum) shows interesting work by both Swiss artists (Füssli, Hodler, Vallotton) and French (Renoir, Rodin, Bonnard), as well as a superb Quentin Metsys, *Christ Giving His Blessing*.

At Oberwinterthur, northeast of the city, industry is the order of the day: **Technorama** showcases various aspects of technology, from household arts to industrial design, from the earliest motors to the latest computers.

Not to be missed is the **Fotomuseum Winterthur**, installed in an abandoned fabric factory, the first and only museum in German-speaking Switzerland devoted entirely to photography. It hosts five important touring exhibitions each year, and its reputation is still growing.

NORTHEAST SWITZERLAND

Commercial, industrial, and nonetheless bucolic, this region extends from Lake Constance (*Bodensee*) to the peaks of the canton of Glarus, encompassing the green and peaceful hills of the Appenzell.

Schaffhausen

Industrial center and communications nexus along the Rhine, Schaffhausen is the capital of Switzerland's northernmost canton, jutting into German territory like a lost puzzle piece. The heart of the old town, today an enjoyable pedestrian zone, includes some of the most beautiful façades of the Swiss past.

Houses from the 16th, 17th, and 18th centuries are adorned with statues, reliefs, sumptuous allegorical frescoes, and richly sculpted oriel windows (these projecting windows are an architectural element often found in the region). In 1570, Tobias Stimmer decorated the façade of the **Haus zum Ritter**, a house in the Vordergasse, with frescoes inspired by Roman myth and history. Note also, among the houses on the **Fronwagplatz**, the imposing **Grosses Haus**, which blends Gothic, Baroque, and Rococo styles. The **Haus zum Goldenen Ochsen**, in the Vorstadt, is a Renaissance house which stands out for the perfection of its sculpted decorations representing the five senses.

To the south, the 12th-century monastery of **Allerheiligen** (All-Saints) now houses a museum rich in illuminated manuscripts and incunabula. It combines a Romanesque church (*Münster*) with a wooden ceiling. The whole structure was restored after severe damage caused in 1944 by American bombers who missed their target.

The **Munot**, a vast circular fortress from the 16th century, dominates the town. From its dungeon, a spiral staircase allows access to the roof, where there is a view of the town, the Rhine flowing through it, and the surrounding vineyards.

Heading downriver from Schaffhausen, you arrive at the **Chutes du Rhin** (Rheinfall), the largest waterfalls in Europe. Shuttles bring you here from town. With a volume reaching 1,080 cubic m (3,543 cubic ft) per second, these falls are as impressive as they are noisy. Take a boat to the promontory, in the middle of the river, where you can feel the full force of the current.

Stein am Rhein, on the right bank of the river (19 km/12 miles east of Schaffhausen), is a wonderful little town. Around the marketplace (Marktplatz) and in the small streets surrounding it, you can find frescoed, half-timbered houses with stepped gables and oriel windows. Some of these buildings are more than four centuries old. Often, their decorations illustrate their names: House of the White Eagle, Inn of the Sun, House of the Red Ox, and so on.

The **Kloster Sankt Georgen** (Convent of St. George), facing the Town Hall, was founded by Benedictines in the 11th century. Today, it is a museum of art and history. You can also visit the monks' cells, which have sculpted ceilings decorated with monochromatic frescoes.

Further along on the banks of Lake Constance, the pretty town of **Kreuzlingen** features the **Basilisk of St. Ulrich** and several historic houses of the 17th to 19th centuries. From here you can take a boat to the **island of Mainau** or cross the border and visit Constance.

Also on the shores of the lake, **Rorschach** has a long-standing commercial tradition, established primarily in the grain industry. Visit the **Kornhaus** (grain depot), built in 1746–1748, which today houses a museum.

Saint-Gall

Capital of lace and textiles, Saint-Gall (*Sankt Gallen*) is located 85 km (53 miles) from Zurich, between Lake Constance and the lower

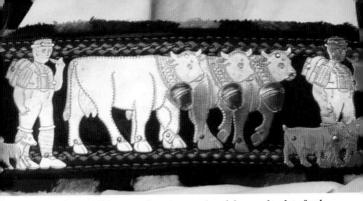

An Appenzell brasswork portrays a cheerful annual trek to fresh alpine pastures.

Alps of northeastern Switzerland. This dynamic city is an excellent example of the successful cohabitation of past and present, where medieval façades rub elbows with modern buildings and trendy bars.

Saint-Gall owes its name and existence to an Irish monk, Gallus, who settled here at the beginning of the seventh century. A hundred years later, a monastery was founded here in his memory, and a city soon sprang up around the abbey, with its houses and artisans' workshops, its school, and its library. Here, erudite monks practiced the arts of manuscript illumination, poetry, and music, making Saint-Gall one of the centers of Germanic culture.

In the old town, various abbatial buildings surround the **cathedral** (*Kathedrale* or *Stiftskirche*), one of the last great Baroque churches built in Europe (in the 1760s). Given the sobriety of the exterior, the white stucco and gold detailing of the interior are all the more striking.

The work these monks devoted themselves to a thousand years ago is conserved at the **Stiftsbibliothek** (Abbey Library), which occupies the west wing of the monastery buildings. Before entering, you will notice above the door the Greek inscription *psyché iatreion*, "apothecary of the soul," a description of the library with which any book-lover would agree. In this room, itself a treasure of Baroque art, the shelves, which reach as high as the frescoed ceiling, contain some 100,000 volumes. The collection of manuscripts and incunabula, one of the richest in the world, alone contains 3,600 works. Manuscripts dating from the ninth to the 16th century are displayed in glass cases, the most precious being Irish, Carolingian, and Ottonian illuminated manuscripts. To find your way around, look up at the cherubs over your head: they indicate the subjects of books in various parts of the room. For example, the one with his eye glued to a telescope is looking at the shelves on astronomy.

The narrow streets surrounding the cathedral contain a profusion of 16th- to 18th-century houses. They are decorated with oriels, painted and sculpted gables, turrets, frescoes, and wrought-iron.

Saint-Gall, named a Free Imperial City in 1212, soon became famous for its production of linen and, later, cotton fabrics. Before World War I, this region produced two-thirds of the embroidered fabrics made worldwide. The techniques and products have changed, but Saint-Gall has retained its title as the Swiss textile capital. To admire some of the most beautiful works of the past, visit the **Industrie und Gewerbemuseum** on the Vadianstrasse, where ancient examples of lace, embroidery, and tapestry have been preserved.

Appenzell

The geographic location and the customs of this region make it one of Switzerland's most traditional, a place that looks entirely like a picture-perfect Swiss postcard.

One of the best times to visit the area is in late June and early July, when the farmers drive the cows up to the high Alpine pastures

(*Alpanfzug*), or when they bring them back down in late August or September. This is a highly festive event: men in traditional red waistcoats, yellow breeches, and hats trimmed with edelweiss flowers lead their herds of cows or goats, who are themselves decked out with large cowbells and flowers. The whole procession resounds with the sound of cowbells, much bleating and mooing, and an occasional outburst of yodelling.

The canton of Appenzell is divided into two parts: Innerrhoden and Ausserrhoden.

The cantonal seat of Innerrhoden is **Appenzell**, a small country town which will enchant you with its wooden houses decorated with bright paintings. In the souvenir stores, you can find handmade Appenzell embroideries, wooden buckets, cowbells, cheeses, and naïve paintings by the local farmer-artists.

If you want to know more about regional art and history, head to the **Appenzell Museum**, located on the Hauptgasse.

Larger than Appenzell, **Herisau** is the cantonal seat of Ausserrhoden; here you will also find a museum devoted to the history and craftsmanship of the region.

If the pastoral charm of this corner of paradise moves you, you won't want to miss the picturesque villages of **Urnäsch**, **Gais** (known for its central square lined with 18th-century gabled houses), or **Trogen** with its own *Landsgemeinde* held every other year. In **Stein** you can learn the secrets of Appenzell cheesemaking (**Appenzeller Schaukäserei**).

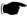

The mountain of **Säntis** (2,503 m/8,212 ft) looms over this region. The roads to the mount end at Schwägalp; from here, a cable car, in service year round, will take you to the top. Before your eyes spreads a panorama which extends from the Bernina range in the Grisons Alps, to Lake Constance.

Grass-roots voting: a show of many hands at Trogen's age-old Landsgemeinde.

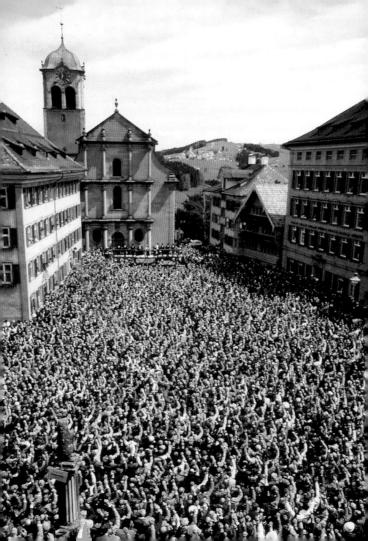

Foreign Intrigue: Liechtenstein

This miniscule country of 160 sq km (100 sq miles), has been a sovereign principality since 1719. During nearly all of the 19th century, it was part of the German Confederation; later, closer ties united it with its neighbor Austria. Its relations with Switzerland have been developing since 1923 and are now so close that its official currency is the Swiss franc.

Vaduz, the capital, has nearly 5,000 inhabitants. The ruling prince lives in a castle high on the hillside, which is not open to the public. However, the finest pieces of the prince's art collection are displayed in the **Liechtensteinische Staatliche Kunstsammlung** (National Art Gallery), located on the Städtle, the city's main street. Changing shows feature the works of the great Dutch and Flemish masters: Pieter Brueghel the Elder, Rubens, Van Dyck, and Frans Hals. The building also lodges a small philatelic museum, the **Briefmarkenmuseum**.

On the same street, the **Liechtensteinisches Landesmuseum** (National Museum) displays Stone Age artifacts and jewelry, Roman coins, and weapons used by Alemanni tribesmen from the fourth to the eighth century, all found in the region, along with a collection of folk art.

Facing the museum, the modern post office building may seem a bit pretentious for a country with only 26,000 inhabitants. But Lichtenstein, thanks to its banking and finance laws, attracts many foreign businesses, some of whom own nothing here but—you guessed it—a post office box.

Beyond Vaduz lie the forests, meadows, and vineyards of the principality, which produce seven important vintages, as well as a sparkling wine.

With its hilly terrain, the principality also boasts a number of charming winter and summer resorts, such as Gaflei, Malbun, Masescha, Steg, and Triesenberg.

NORTHWEST SWITZERLAND

Northwest Switzerland is the region encompassing the four German-speaking cantons, which include Basel-Stadt, Basel-Land, Solothurn, and Aargau.

Basel

The principal metropolis in northwest Switzerland, Basel ($B\hat{a}le$) is the second largest city in the country. It is also a major Rhine port linking Switzerland and the sea; it is from here that Swiss exports begin their journey down the Rhine to Rotterdam. An international commercial crossroads, this great industrial center is nonetheless quite charming thanks to parks large and small, interesting architecture, and, always, the river itself.

France and Germany are a stone's throw away; in one day you can cross the mysterious Black Forest, have lunch in Alsace, and visit one of Basel's famous museums. The cosmopolitan character of the city is fed not only by the economic power it holds over its neighbors, but by its role as a university town with a lively cultural life.

In the seventh century, Basel acquired its reputation as a great cultural center. In 1033, the Germanic emperor Konrad II captured the town from the Burgundians, and Basel remained German until 1501; that year, it became the eleventh member of the Swiss Confederation. In 1521, when the famed Erasmus chose to teach here, the city (whose university, founded in 1460, is the country's oldest) became one of the great humanist centers north of the Alps.

Today, Basel is Zurich's rival for the title of Switzerland's richest city. Three hundred years ago, the bourgeoisie made its living in the silk trade; nowadays, the pharmaceutical and chemical industries are the primary source of wealth. Each year, the Industrial Fair attracts more than a million visitors, and its stock exchange is fast catching up with Zurich's.

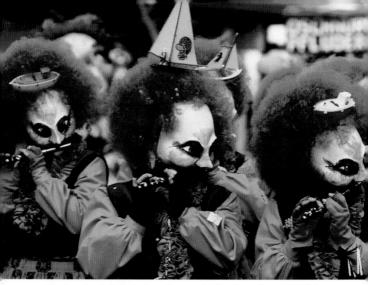

Buskers let their hair down for carnival, a three-day spectacle in the streets of Basel.

Visiting the City

Let us begin with the **Mittlere Rheinbrücke** (Middle Bridge), where you can enjoy an excellent view of the whole city, crowned by the cathedral and the magnificent medieval buildings that surround it.

Make your way into **Kleinbasel** (Little Basel): from the Oberer Rheinweg you have a splendid view of **Grossbasel** (Greater Basel). Grossbasel is older and more aristocratic; don't miss the sculpture on the building at Schifflände 1, of the **Lälle-Keenig**, a medieval king sticking out his tongue. This is Grossbasel's way of showing its contempt for its little brother. But Little Basel gets to have its say on the Day of the Gryphon (*Vogel-Gryff*), when the Wild Man (*Wilde* *Mann*), riding by on a raft, climbs the bridge and does an insolent dance. This burlesque ceremony, which occurs every year in January, sets the tone for the riotous Carnival period.

Climb the streets of Rheinsprung and Augustinergasse, lined with lovely old houses, up to the **Münsterplatz**; this perfectly proportioned square hosts a **Münster** (church) that has hardly changed since the 12th century.

Note the detailing on the Gothic sculptures of the main portal. Then take a tour of the building, ending at the Galluspforte, a beautiful Roman doorway which used to be the main entrance to the cathedral. Inside, visitors always stop to read the epitaph of Erasmus, who died in Basel in 1536.

The **Stadttheater** (Municipal Theater) is a big modern building in the Theaterstrasse, facing a terraced square with a whimsical mechanical fountain by Jean Tinguely, the **Fasnachtsbrunnen**. The latter is a humorous mixed media construction, representing nine characters spitting into the water.

The three main commercial streets—Freiestrasse, Falknerstrasse, and Gerbergasse—all lead to the **Marktplatz**, where you can mingle with the locals and buy fruit, vegetables, and flowers. On the square where the market is held stands one of the most striking buildings in all of Basel, the 16th-century **Rathaus** (Town Hall). It is adorned with small round turrets, larger towers, arches, Renaissance windows, and a glittering gold steeple. The whole edifice, painted a vivid bright red, seems like a gigantic, surreal model —almost like a dollhouse.

In the 14th century, the citizens of Basel conceived the ambitious project of surrounding the city with a protective wall, which was finished in 1398. The urbanization plans of the 19th century left little of it standing, but one true jewel was saved: the **Spalentor**, the Western gate to the city, topped by a clock tower and flanked by two crenellated guard towers. The sculptures of the Virgin and the prophets were added in the 15th century.

For a change of atmosphere, head for the **St. Anton church** (1927). Designed by the architect Karl Moser, this is one of the first churches built in reinforced concrete. Its extremely simplified forms are intercut with huge clear windows, while its rectangular, elongated double tower pierces the sky, dominating the whole neighborhood.

For another example of contemporary architecture, take a look at the seat of the U.B.S., conceived by Mario Botta, a Swiss native from the Ticino. This unassailable citadel is clothed in unlikely colors: blue and nebulous white.

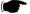

Children and grownups alike will appreciate the **Zoologischer Garten** (called the Zolli for short), located southwest of town, not far from the train station. With its 4,000 animals of 600 different species on 13 hectares of land, it is the largest zoo in Switzerland. Founded more than a century ago, this serious institute of scientific study was the first zoo in Europe where gorillas, rhinoceros, and other species reproduced in captivity. At the zoo's entrances, banners inform visitors of new births and list the mealtimes for different animals, the elephants' bath-time, and other events and items of interest for the day.

Basel's Museums

Few museums in the world can rival the riches of the prestigious **Kunstmuseum** (Fine Arts Museum). The first museum to open to the public in Europe, it is also the most well-attended museum in Basel. The old masters still hold the position of honor here, but this museum has kept pace with the times, adding to its collection of classics with many works by artists as modern as Rothko, Jasper Johns, Calder, and Newman. The modern collections also include a good number of Picasso's late works. Among the most popular pieces on display here are those of Jean Tinguely, whose whimsical, fanciful creations delight both adults and children. Some of the best represented artists include Konrad Witz, Martin Schongauer, Hans Baldung Grien, Dürer, Rembrandt, Basel native Arnold Böcklin,

A more tranquil street scene: one of Basel's bright, charming old-town lanes.

Monet, Gauguin, Picasso, Braque, Max Ernst, Dali, Chagall, Giacometti, and Paul Klee.

From the Kunstmuseum, it takes just a ten minute walk to reach the **Museum für Gegenwartskunst** (Museum of Contemporary Art), which is located on the banks of the Rhine. The structure this museum is housed in was once an old paper mill; it was coverted to hold the contemporary collection in 1980. The main hall, lined with glass, houses Jonathan Borofsky's *Flying Man*, hanging at a thirdfloor height. The conceptual and minimalist creations of Frank Stella, Donald Judd, Carl André, and Joseph Beuys stand in contrast to the extravagant new expressionism of Mimmo Paladino, Enzo Cucchi, and Francesco Clemente. The new generation of Swiss artists is also well represented. The museum chronicles recent developments in the art world, including some of its more controversial ones.

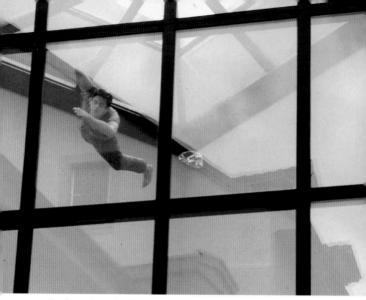

Look again—the Museum of Contemporary Art's "Flying Man" is only a statue.

In the same contemporary spirit, the **Kunsthalle** has been presenting new names and trends in changing temporary exhibitions for more than a century.

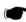

In the Solitudepark, a pastel-pink sandstone and glass building designed by Mario Botta houses the **Jean Tinguely Museum**. The collection retraces 35 years of this artist's output: note, in particular, the *Homage to New York* (1960) and *Lola* (1980).

The **Beyler Foundation**, located in Riehen, contains a remarkable array of works: among the Impressionists are canvases by Cézanne, Van Gogh, Monet; Picasso and Braque figure among the Cubists, and there are striking works by Miró, Matisse, Mondrian, and Kandinsky. American pop is represented by Warhol, Rauschenberg, and Lichtenstein.

Not far from the Beyler Foundation, on the German side of the frontier in Weil am Rhein, Vitra, a world-renowned furniture manufacturer, offers visitors an extraordinary journey through the world of architecture and design. The **Vitra Design Museum** illustrates the evolution of industrial furniture design from 1820 to the present. The museum, which has amassed a world-class collection over the years, includes a center for acquisitions, design, and research. The buildings making up the Vitra center were designed by some of the greatest architects of our time. Conceived by Frank O. Gehry, the main building is composed of a juxtaposition of stunningly shaped masses and volutes in radiant white, studded with glass. Nearby, the firehouse where the chair collection is housed was designed by the architect Zaha Hadid, a woman with ingenious ideas. A wall of smooth concrete hides a garden filled with cherry trees, where you will find a pavilion by the famous Tadao Ando.

Last but not least, there is Basel's interesting specialty museum, the **Basler Papiermühle**—the Swiss museum of paper, writing, and typography.

Fifes and drums

The Basel Carnival (Fassnacht) is famous throughout Europe. It is a colorful three-day festival, with masks, drums and fifes, extraordinary costumes, and giant lanterns. The Monday after Ash Wednesday, at 4am, all the lights of the city go out; after a few impressive minutes of silence, the lanterns are lit and, all over the city, the dance groups begin their march to the haunting rhythm of fifes and drums: this is the Morgestraich. While processions ebb and flow through the narrow streets, politicians become fair game for satirists, restaurants and cafés fill to the brim, and work and business take second place, or surrender completely.

Major Sights — Basel and Vicinity

Augusta Raurica: Giebenacherstrasse 17, 4302 Augst; Tel. (061) 816-22-22; website http://augusta-raurica.ch; Roman Museum Mon 1–5pm, Tue–Sun 10am–5pm (closed 12–1:30pm Nov–Feb); Animal park and pavilions Mon–Sun 10am–5pm (10am–4:30pm Nov–Feb); 3–5FS

Baseler Papiermühle (Swiss Museum of Writing and Typography): St. Alban-Tal 37; Tel. (061) 272-96-52; Tue-Fri 2-5pm; 6-9F, families 22FS

Beyler Foundation: Baselstrasse 101, 4125 Riehen; Tel. (061) 645-97-00; e-mail fondation@beyeler.com; website http:// www.beyeler.com; Mon, Tue, Thu-Sun 11am-6pm, Wed 11am-8pm; 6-14FS; special rates for temporary exhibitions

Eglise de St. Anton: Kennenfeldstrasse 35

Kunsthalle: Steinenberg 7; Tel. (061) 206-99-00; Tue, Thu–Sun 11am –5pm; 6–9FS

Kunstmuseum (Fine Arts Museum): St. Alban-Graben 16; Tel. (061) 271-08-28; website http://www.kunstmuseumbasel.ch; Tue–Sun 10am–5pm; 5–7FS (incl. Museum of Contemporary Art)

Mario Botta/Union of Swiss Banks building. Aeschenplatz

Museum für Gegenwartskunst (Museum of Contemporary Art): St. Alban-Rheinweg 60; Tel. (061) 272-81-83; e-mail mgk.basel@bluewin.ch, website http://www.kunstmuseumbasel.ch; Tue-Sun 11am-5pm; 5-7FS (incl. Museum of Fine Arts)

Museum Jean Tinguely: Grenzacherstrasse, Solitudepark; Tel. (061) 681-93-20; website http://www.tinguely.ch; Wed-Sun 11am-7pm; 3–5FS; children under 16 free

Vitra Design Museum: Charles-Eames-Strasse 1, 79576 Weil am Rhein, Germany; Tel. (49) 7621-7023-200; e-mail info@design-museum.de; website http://www.design-museum.de; Tue-Sun 11am-6pm; 6-10Dm, 13Dm (2-hour guided visits in German begin at 2pm)

Zoologischer Garten: Binningerstrasse 40; Tel. (061) 295-35-35; Mar–Apr 8am–6pm, May–Aug 8am–6:30pm, Sep–Oct 8am–6pm, Nov–Feb 8am–5:30pm; 4–10FS, children under 6 free

Excursions from Basel

A fifteen minute drive is enough to land you at any of the many charming sites located in the Basel countryside.

To the south, **Arlesheim**, a lovely village surrounded by forests, fields, and cherry orchards, has a Baroque church (*Domkirche*) and pretty 18th-century houses built for the canons of the bishopric of Basel, which are worth visiting.

A bit further south, **Dornach** is dominated by the extraordinary **Goetheanum**, a revolutionary theater designed by Rudolf Steiner, founder of the Anthroposophic movement. His thoroughly expressionist architecture eschews all right angles. The name is an homage to Goethe, from whose work Steiner drew his philosophical inspiration (and whose plays often resonate in this space).

The frontiers of three countries converge at this watery corner of Basel.

To the east of Basel, **Augst**, the ancient city of Augusta Raurica, is sometimes called "the Swiss Pompeii." The 20,000 inhabitants of this flourishing Roman outpost (founded around 44 B.C.) enjoyed a theater, a temple, a forum, and baths, whose ruins are still visible. In the summer, productions are put on in the outdoor theater. A museum preserves all the artifacts found in digs at this site.

Solothurn

This small town is built on the Aare River, at the foot of the Jura range, around 65 km (41 miles) south of Basel and 38 km (24 miles) north of Bern. Solothurn's past goes back to Roman times, but it is the Baroque atmosphere that gives the town its special charm. In the 17th and 18th centuries, Solothurn (*Soleure*) the town, having resisted the Reformation, became the place of residence for ambassadors and envoys from Catholic France, who settled down in fine patrician mansions.

The monumental **Sankt Ursenkathedrale** (Saint-Ursen Cathedral) is built in a remarkable Baroque Italian style. Its treasures include many precious relics, including the Hornbach Missal, an illuminated manuscript from the tenth century.

The **Altes Zeughaus** (Arsenal), dating from the 15th century, is close to the main street (Hauptgasse). It contains a fine collection of arms and uniforms from the Middle Ages to the present day.

As you stroll down the Hauptgasse, you will see the **Jesuitenkirche** (Jesuit Church), a Baroque building completed toward the end of the 17th century. The best place to look out on the 12th-century **Zeitglockenturm** (clock tower) is from the terrace of a café on the market square. This astronomical clock, which is meticulously decorated with tiny figures, is over four centuries old.

Solothurn boasts many small city squares, each one with its own historic fountain. Notice the old houses with their heavy, overhanging roofs and dormer windows of a peculiar local design. Two medieval gateways, the Bieltor and the Baseltor, guard the entrance to the old town.

Beyond the fortifications, in the Werkhofstrasse, stands the **Kunstmuseum** (Fine Arts Museum), which is worth a visit, if only to see the masterful *Madonna of Solothurn*, by Hans Holbein the Younger.

Baden

Twenty-two km (14 miles) northeast of Zurich, Baden (literally, "Baths") wears its name well. Two thousand years ago, the Romans were already taking dips in the hot springs of the *Aquae Helveticae* (Swiss waters). Today, people "taking the waters" enjoy luxurious surroundings in local hotels or municipal baths. Rich in mineral salts, these waters are recommended for the treatment of rheumatism, as well as for neurological, respiratory, and cardiovascular problems.

Begin your visit at one of the highest points in the city: the park facing the casino (*Kursaal*), or the modern bridge spanning the Limmat river. From here, the view of the old town stretches out before you, down to the water.

Baden's **clock tower** (*Stadtturm*), constructed in the late Gothic style, dominates the old town. The crenellated wall that climbs the hill connects the clock to a fortress, in ruins since the beginning of the 18th century.

Inside the 15th-century **Rathaus** is an historic room (*Tagsaztungssaal*), where the representatives of the thirteen original cantons met regularly between 1424 and 1712.

If you follow the ancient, winding streets back to the river, past a covered bridge from the 19th century, you will end up at the **Landvogteischloss** (Bailif's castle). Inside, a museum displays armaments and other artifacts from the canton of Aarau.

The Sydney and Jenny Brown galleries at the Langmatt Collection (Römerstrasse 30) feature a sizeable selection of Impressionist works.

BERN AND VICINITY

The canton of Bern, second largest in area of all the Swiss states, stretches from the French border in the northwest to the heights of the alps in the south. Because of the diversity of the terrain, its towns, and natural attractions, the tourist authorities tend to divide it

in two: the federal capital and the northern part of the region as one unit, and Interlaken and the alpine resorts—the Bernese Oberland —as another.

Bern

Bern (*Berne*), capital of the Swiss Confederation since 1848 and considered one of the best-preserved medieval cities on the Continent, is listed by UNESCO as one of the world's cultural treasures. It is also one of the most "blooming" towns in Europe: in addition to its many public gardens and forests, the façades and historic fountains are covered in flowers.

The city, seat of the federal government and of numerous diplomatic offices, as well as various international organizations

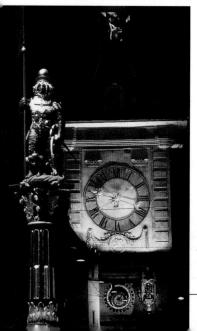

(including the Universal Postal Union), remains an enclave of romantic calm.

But Bern has eight centuries of often quite tumultuous history behind it. The city was founded in 1191 by Duke Berchtold V of Zähringen, who, looking for an impregnable bastion at the western frontier of his lands, decided to perch it on a rocky projection that was formed by a curve in the Aare river. In 1405, after a fire that destroyed nearly all its wooden houses, Bern was rebuilt in sandstone.

A sculpted bear, all decked out and ready for battle, guards Bern's famous clock tower. The bear representing the Zähringen family is everywhere: in statue form, on the flag, and even alive and well in the popular Bear Pit. Legend has it that when the Duke decided to build the city, he swore to name it after the first animal he brought back from the hunt; that animal turned out to be a bear (*Bär*, in German).

In 1353, after fighting the Hapsburgs to defend its independence and freedom, Bern joined the Confederation. The expansion of its holdings to the west brought the French-speaking regions into the Confederation. During the constitutional assembly of 1848, Bern was chosen to be the seat of the federal government.

The Old Town

Begin your exploration of ancient Bern at the train station: you will discover that the underground shopping galleries here contain the remains of the Christoffelturm (Saint Christopher Tower) which, six centuries ago, were an integral part of the ramparts of the city.

If you take the escalator to street level, you emerge at the start of a lively shopping street, the **Spitalgasse**, where major department stores hide behind elegant old façades. Most of the streets of the old town are covered by arcades, making up a promenade 6 km (4 miles) long. Under the arcades, you can stroll peaceably in any weather, enjoying musicians and street artists along the way.

Bern is full of **fountains**, most of them dating from the 16th century. Their central columns generally support allegorical figures painted in bright colors. The first fountain you will come across is the Pfeiferbrunnen (Bagpiper Fountain), which is probably the work of Hans Gieng, who designed many of these attractive local landmarks.

The **Käfigturm** (17th century) was once a watchtower, later a prison. Take a left onto the Waisenhausplatz, where you will see to your north the Waisenhaus (orphanage), a beautiful 18th-century building. The modern fountain nearby, designed by Meret Oppenheim, is a controversial addition.

South of the Käfigturm, the Bärenplatz, with its cafés and giant, open-air chessboards, is always lively.

Return to the Käfigturm and take a right on the **Marktgasse**, with its two distinctive fountains: one is an allegory of Temperance—a woman diluting wine with water—in homage to Anna Seiler, founder of the Island Hospital, who donated her house to take in victims of epidemics—while the other, the Schützenbrunnen (Arquebusier Fountain), is decorated with a flag-bearer. An ogre is the subject of the **Kindlifresserbrunnen**, located on the Kornhausplatz (on your left at the end of the Marktgasse). The **Kornhaus**, once a grain depository, is now a cultural center hosting exhibitions and other events. This group of buildings also includes the Fine Arts and Industrial Arts libraries. Don't hesitate to take a seat in the Kornhaus Café, a successful combination of ancient walls and modern touches.

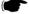

The famous **Zygloggeturm** (clock tower), the oldest monument in Bern, is so unusual you might want to organize your visit around it, so you can witness this extraordinary display of 16thcentury Swiss clockwork. Arrive at least five minutes before the hour and get ready to take in the show: a jester contorts himself to ring two bells above his head, a procession of bears follows, a rooster crows and flaps his wings, Father Time turns over his hourglass, and so on.

Beyond the Zytglogge, on the **Kramgasse**, the Zähringerbrunnen (Zähringen Fountain) is topped by a bear in armor, with a baby bear at his feet. The *Mutz*, as Bern natives have nicknamed him, was built in honor of the city's founder. Albert Einstein and his family lived from 1902 to 1909 at number 49 on the Kramgasse. The apartment where the physicist developed his theory of relativity and the law of the equivalence of matter and energy has become a small museum.

At the bottom of the street and to the right, the **Rathaus**, a ravishing Gothic construction, rises between the Postgasse and

This annual festival in Bern offers everyone the opportunity to celebrate the humble onion.

the Postgasshalde, facing the colorful Vennerbrunnen (Flagbearer Fountain), which shows a Bernese standard bearer in full uniform.

As you continue along the Kramgasse, the **Gerechtigkeitsgasse** features the **Gerechtigskeitsbrunnen**, a fountain representing the allegory of Justice.

At the end of the street, you are faced with two tempting choices: you can cross the bridge and go straight to the Bear Pit, or take a left on the Nydeggstalden to the oldest part of town. After the Nydeggkirche (Nydegg Church), head down to the Läuferplatz to see the **Untertorbrücke**, the oldest bridge in Bern (1461–1489). To the left, the Läuferbrunnen (Messenger Fountain) pays homage to a herald from Bern who, reproached by the king of France for not speaking French, had the audacity to reply: "Well, you can't speak German!"

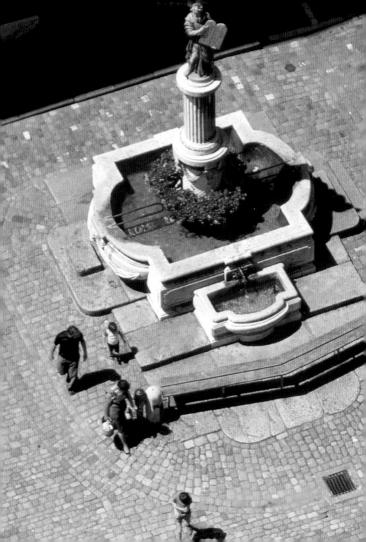

To get to the **Bear Pit** (*Bärengraben*), turn right after the Unterbrücke and follow the ramp. Bern without its bear would be like Paris without the Eiffel Tower. Bears have occupied the place of honor here since the 15th century—with the exception of the period of French occupation, during which time the mascots were confiscated. The crowd is at its most dense on Easter morning, when, if weather permits, the mother bears and their new cubs are brought out for the first time each year.

Cross back over the Nydeggbrücke and walk up the Junkerngasse to the **Münster**, Switzerland's most majestic cathedral built in the late Gothic style. It took more than two centuries to complete. The nave, begun in 1421, was only finished 150 years later, and not until 1893 was the openwork spire, 100 m (328 ft) high, added. The largest of the bells, weighing more than ten tons, was put in place in 1611. The *Last Judgment* (1490–1495), a remarkable work by Erhart Küng (on the tympanum over the main entrance) represents a series of 234 damned and chosen souls, "recruited" from every social class.

In the choir, the beautiful 15th-century stained-glass windows illustrate, in particular, the three kings and an impressive *danse macabre*; don't miss the magnificent Renaissance choir stalls. A staircase leads to the second terrace of the tower, with a splendid view of the city. From the Münsterplattform, an amazing elevator takes you to the riverbank, in the old popular neighborhood of Matte. Now renovated, it is full of boutiques, crafts stands, and artists' studios, and makes for a very agreeable walk.

Right nearby, the **Bundeshaus** (Federal Parliament Building) is the seat of Swiss government, built in the 19th century. The building can be visited anytime except during Parliamentary sessions and on holidays (free guided visits are offered six times a day). During sessions, the visitors' galleries are open.

A view down to the Moses fountain and courtyard from Bern's late Gothic cathedral.

For a brief excursion, you can climb the **Gurten** (858 m/2,185 ft high), where the view of Bern and the surrounding Alps is extraordinary. It takes about 25 minutes to get to the summit by tramway (the number 9 line), or about ten minutes with the funicular running out of Wabern, just south of the city center.

Bern's Museums

The **Kunstmuseum** (Fine Arts Museum), at 12 Hodlerstrasse, is famous for its extensive collection of Paul Klee, who was born in Bern and who died here in 1940. These works—over 2,500 in all—along with canvases by other 20th-century artists (Picasso, Kandinsky, Kirchner, Miró, etc.) have been installed in a splendid wing of the museum, built in 1983. The museum also houses works by Fra Angelico, as well as those of 19th- and 20th-century artists like Delacroix, Cézanne, Albert Anker, and Ferdinand Hodler.

The **Kunsthalle** (Art Institute), located at Helvetiaplatz 1, is devoted to contemporary art and welcomes temporary exhibitions of avant-garde works.

Mountain lovers will rush to the **Schweizerisches Alpines Museum** (Swiss Alpine Museum), at Helvetiaplatz 4, where topographic reliefs of the mountains and other maps are on display alongside antique ski and climbing equipment.

The **Schweizerisches PTT-Museum** (Swiss Postal Museum), installed on the first floor of the same building, tells the story of the postal service, the telegraph, and the telephone, from the time of dispatches and the earliest centralized phones to the most modern teleprinters. Rare stamps, both Swiss and foreign, are on display in the basement. The collection contains some of the world's most precious stamps.

The **Bernisches Historisches Museum** (Bern Historical Museum), at Helvetiaplatz 5, is lodged in an extraordinary building in the neo-Gothic style, built in the last century. It contains artisanal objects as well as armaments, figurines, and jewelry. Its most pre-

cious possession is the booty seized from the Duke of Burgundy in the battle of Grandson (1476): including battle standards, manuscripts, and precious tapestries.

The collections of the **Naturhistorisches Museum** (Museum of Natural History), at Bernastrasse 15 (right near the Historical Museum) figure among Europe's richest. Zoology, geology, mineralogy, and paleontology are well represented and well displayed.

A little apart from the other museums, at Schanzenstrasse 15, stands the **Schweizerische Theatersammlung** (Swiss Theater

The countryside surrounding Bern comprises a lush landscape of rolling green hills.

Collection). The way the objects are presented here is as remarkable as the objects themselves. The history of theater unfolds before your eyes, illustrated by scale models of theaters from ancient Greece and Rome through the Middle Ages, the Renaissance, and up to the present. The library has thousands of volumes, press clippings, posters, and videos.

Other Places of Interest

If modern architecture and unusual discoveries are what interest you, take a walk across the Monbijoubrücke: the **Titanic**, rising up abruptly in the middle of a residential neighborhood, is an enormous ship-shaped building covered with gray metal scaffolding and a network of exterior ladders. Built recently, this resolutely modern and forward-looking edifice is an administrative building that houses a number of federal offices.

Returning to the center of town, tour the **Markthalle**, on the Bubenbergplatz, alongside the train station. Here, you will find a shopping gallery, a covered market, a culinary bookstore, and many bars and restaurants serving cuisine from the four corners of the world, all under the same roof. This harmonious place, convivial and full of charm, was designed tas a renovation project on a former linen factory, many elements of which have been preserved and integrated into the decor.

Biel

Prehistory and modern industry live side by side in Biel (*Bienne*), a city of rivers, streams, and canals, situated along the lake of the same name (about 32 km/20 miles northeast of Bern). Its many watchmaking firms give it its nickname, "the Swiss watch capital."

The city gets its special character from its bilingual meeting of two cultures (two-thirds of the population speaks Swiss German, one-third French). The Biennese juggle the two languages without ever mixing them up. The old town, whose medieval mansions have been painstakingly restored, invites the visitor for a leisurely stroll, particularly beneath the arcades of the **Obergasse**. Here, as in Bern, the 16th-century fountains draw the visitor's gaze with their boldly colored statues. Notice the Vennerbrunnen (Flagbearer Fountain), on the **Ring**, a central plaza surrounded by an impressive architectural ensemble.

The Biennese take their prehistory to heart. It was a native of Biel, Friedrich Schwab (1803–1869), who discovered at La Tène (on Neuchâtel Lake) the vestiges of a second Iron Age culture. The objects he excavated, belonging to the

A bust of Jean-Jacques Rousseau graces a place he loved well: St. Peter's Island, on Lake Biel.

ancient civilization now known as the La Tène, have been gathered in the Biel museum named after Schwab.

As far as more recent history is concerned, it should be mentioned that Biel is the birthplace of the Swatch, that famous and fun plastic watch which has fundamentally changed our attitude toward that particular object. The Swatch will no doubt remain a symbol of the modern period, a household-name product available to everyone.

From Biel, it takes about an hour and a half to walk out to the **Taubenloch gorges** (Taubenlochschlucht). A footpath leads to this site of wild beauty, known as the "gateway to the Jura mountains." Evilard, a little village perched on the hills above Biel, offers a

marvelous view of the high peaks in the Bernese Oberland lying beyond Bern.

In fifty minutes, a boat will take you to **Saint Peter's Island** (*Sankt Petersinkel*), on the lake of Biel. This nature preserve is an island only in name, since during the last century drainage lowered the water level, turning Saint Peter's into a peninsula connected to the mainland. In the 18th century, Saint Peter's Island so captivated that "friend of nature" Jean-Jacques Rousseau that he stayed here from 1765 to 1767. The hotel room where he lived, full of mementos, still attracts nostalgic visitors.

The Emmental

Everything about Switzerland that is rural, green, peaceful, and perfectly clean is summed up by the Emmental. Even the most urban visitor will soon admit that the timeless aspect of this region is impossible to resist.

Twenty-two km (14 miles) northeast of Bern, **Burgdorf** (*Berthoud*), which overlooks the Emmental Valley, is a center for the textile industry. The restored 12th-century castle holds a small museum of local history. From Burgdorf, a pretty road follows the valley of the river Emme (which gives its name to the region) to the big village of **Langnau** (30 km/19 miles from Bern). Besides its interesting folk museum and fog-free climate, Langnau offers an excellent sweet cheese studded with large holes—Emmental.

BERNESE OBERLAND

Lying to the south of Bern, the Oberland is a region with much to offer the tourist: majestic mountains, glaciers, lakes and cascades, charming villages, and well-equipped vacation resorts. Since the beginning of the 19th century, well before skiing and hiking became popular pursuits, the English and French elite came here to relax in luxury hotels and to see, far off, the peak of the Jungfrau. The more adventurous among them went as far as the glaciers.

Around Thun Lake

Thun (*Thoune*), tucked into the northernmost edge of the lake of the same name, occupies a remarkable site: the center of the old town sits on a long, narrow island on the Aare, just where the river flows out of the lake. This island, small enough to cross easily on foot, is linked to dry land by several bridges. In the northern part of the island, the **Hauptgasse**, the main commercial street in Thun, is curiously built on two levels, so that you walk on top of the flower-lined roofs of the stores that line it while admiring the windows of a second level of boutiques.

At the end of the street, between numbers 55 and 57, take the covered staircase leading to the castle and the Baroque parish church. The **Schloss Thun** is a group of fortifications crowned by a square Romanesque tower topped with a smaller tower at each corner. The **Historisches Museum** (Historical Museum), founded in 1888, occupies three floors of the dungeon. The main room is the Knights' Room, a majestic chamber hung with 15th-century tapestries, where picks and halberds are on display. On the floor above are Swiss military uniforms and armaments from the ancient crossbow to modern-day weapons. On the floor below, you will find artisanal works from the Oberland region, as well as a collection of toys.

Old steamboats cross the Thun Lake, offering pleasant minicruises. Along the north bank, a road leads from the lake to the hills, ending at **Oberhofen**. This town is known for its medieval castle, which was reconstructed and sumptuously decorated during the 17th and the 19th centuries, and houses a section of the Bern Historical Museum.

On the south bank of the lake, **Spiez** also has an imposing castle from the 12th and 13th centuries. Don't miss the magnificent panoramic view from the **Niesen**, (2,632 m/8,635 ft), an impressive natural pyramid. To reach the top, take the funicular from Mülenen, about 2 km (1 mile) south of Spiez.

Several ski lodges can be conveniently reached from Spiez. If you take the road through the Simmental, you will reach **Gstaad**, a fashionable resort where celebrities from the world over come to ski and be seen. Nearly all winter sports can be practiced here, in an atmosphere that is not only chic, but surrounded by great natural beauty.

Adelboden. Deep within the Engstligental region, this pleasant and booming vacation spot is known for its healthful climate and small-town atmosphere, in summer as well as winter. The much smaller town of **Kandersteg** is a great hit with mountain-lovers.

Interlaken

This famous ski center is located, as its name indicates, "between the lakes" of Thun and Brienz. Interlaken owes its renown in partic-

Interlaken's vast central park and incomparable views of the Alps explain the town's worldwide fame.

ular to the view it offers of the Jungfrau mountain, with its perpetual coat of snow.

Höheweg (or Höhe), a magnificent boulevard shadowed by trees, offers gorgeous views of the surrounding peaks. You can get around by horse-and-carriage or on foot. The north side is occupied by grand Victorian hotels, restaurants, boutiques, and the famous casino (*Kursaal*). The sunnier and more open southern part features a beautiful park, the **Höhematte**, with a view that opens onto the Jungfrau. Strollers can easily escape the crowd by tackling one of the many pristine hiking trails.

From Wilderswil, 2 km (1 mile) away, a cog railway climbs up to the **Schynige Platte**. In addition to a superb panorama of the Bernese Alps, this site offers visitors a garden of alpine blooms.

Toward the Peaks

Train enthusiasts and armchair alpinists will have a hard time resisting the attraction of a comfortable journey from Interlaken to Jungfraujoch, the highest train station in Europe (3,454 m/ 11,332 ft). In clear weather, the spectacle is one of a kind, and the air extraordinarily pure.

From Interlaken, you can make part of the journey by car to **Grindelwald** (a lively international ski resort) or Lauterbrunnen. From either place, the train will take you to the Jungfrau.

The construction of this railway—the **Jungfraubahn**—was one of the great technological achievements of the end of the last century. It climbs in a spiral, through tunnels carved into the rock face of Mount Eiger.

Whether you come from Grindelwald or Lauterbrunnen, you will reach the Jungfraubahn at the **Kleine Scheidegg** (Little Scheidegg) station, at the foot of the awe-inspiring northern slope of the **Eiger**, first conquered in 1938. This peak is surrounded by the soaring peaks of the **Wetterhorn**, the **Mönch**, and the **Jungfrau** (4,158 m/13,642 ft).

The train then enters an almost continuous series of tunnels (7 km/4½ miles) after the Eigergletscher station, where the Eiger glacier looms into view. The train will stop twice more, briefly, at Eigerwand (the Wall of Eiger) and Eismeer (the Ice Sea), for passengers to get out and get a glimpse of the marvelous view through the "picture windows" carved in the rock.

The last station, and the most surprising, is the **Jungfraujoch**. Hotels, restaurants, and a terrace dominate the Aletschgletscher, the longest of the Alpine glaciers at 25 km (15½ miles). Dress warmly, even in summer, and wear appropriate shoes: if weather permits, you can go for a walk (but stay inside the signposted paths and safe areas) or take a ride in a dogsled. The ice sculptures on view at the "Ice Palace," as well as a small exhibition on scientific research at high altitudes, are definitely worth a look.

Another excursion to undertake in good weather is a trip to the **Schilthorn mountain**, which offers a fine view of the Alps. From Stechelberg and **Mürren** (a romantic village completely without cars, perched on a veritable "balcony" facing the Eiger, Mönch, and Jungfrau mountains), a cable car climbs to a height of 2,970 m (9,744 ft) to leave you at the foot of the revolving restaurant of the Schilthorn. It takes 50 minutes for the turning platform to complete one rotation, allowing plenty of time for gazing out over the Bernese Alps, Mount Blanc, and the Jura and Vosges mountain ranges. And who could forget that James Bond made his own trip here?

Don't leave this region without having seen the **Trümmelbach Waterfalls** (3 km/2 miles from Stechelberg). An elevator will take you to the well-lit galleries, where the impressive cascades burst from underground gorges. Don't forget to take a raincoat.

Brienz Lake

A small blue marvel with wilder and more dramatic surroundings than those of its brother, Lake Thun, the Brienzersee is linked to the Thun by the Aare River. The town of **Brienz**, on the easternmost point of the lake, is the Swiss capital of wooden sculpture. The city also has a school of wood sculpture, another for the handcrafting of string instruments, and, of course, several souvenir stores.

The **Brienzer Rothorn** looms over the region from its height of 2,530 m (8,300 ft). Go up in one of the old-fashioned railway carriages pulled by a steam engine. The hour-long journey up the Rothorn reveals scenes of tranquil, breathtaking beauty.

Cogs and Cable Cars

You can always climb a Swiss mountain with crampons, a pick, and some rope. But another way to breathe the pure air of the peaks is to gleefully reject the hard way and take advantage of technology—technology that, in Switzerland, is breaking records by leaps and bounds.

Since the end of the 19th century, the cog-wheel railways have made communications possible over the mountains. The Viznau-RigiBahn, finished in 1871 by the Swiss engineer Riggenbach, is the oldest cog train in Europe. The Pilate, which travels on the world's steepest tracks (48°) has been running since 1889. In Zermatt, one of these trains goes as high as Gornergrat. Finally, the highest train in Europe is the Jungfraujoch train, which reaches an altitude of 3,454 m (11,332 ft).

Cable cars often pick up the next leg of the climb, easily crossing the most difficult zones. The highest line in Europe links Zermatt to the Matterhorn, at over 3,800 m (12,467 ft).

Saas-Fee boasts an Alpine subway. This underground route goes from the Felskinn cable car stop (3,000 m/9,838 ft) to end at Mittelallalin (3,500 m/11,483 ft). And this subway is also—to no one's surprise—the highest in the world.

Flowers galore adorn a characteristically tidy chalet in the central Swiss countryside.

One tried-and-true excursion begins with a boat or car ride to the wooded bank of the lake facing Brienz; then, from Giessbach See, a funicular transports travelers to the **Giessbach Falls**, a superb series of waterfalls which hurtle straight down from a height of 400 m $(1,312 \, \text{ ft})$. Simply one of the most romantic spots imaginable, Giessbach is home to an old hotel which has been beautifully renovated.

Each village and market town of the Oberland has a church, a town hall, and a folklore museum. None, however, is as ambitious as the **open-air museum of Ballenberg** (open from mid-April to the end of October), about 2 km (1 mile) northeast of Brienz (on the route to Brünig). The "Ballenberg," whose official name is the *Schweizerisches Freilichtmuseum für ländliche Bau- und Wohnkultur*, groups together actual village houses, some more than three centuries old, brought here from all over the country. Seeing them together underlines the multiplicity of styles, materials, and methods in Swiss construction: the Oberland chalet, for example, with its low roof and highly wrought facade (the "music-box

chalet" famous the world over), is entirely different from the typical house of central Switzerland, in wood and masonry. The interiors are all authentically furnished, and the houses are complete with back-yard vegetable gardens and farm animals. Here and there, artisans are on hand to demonstrate their craft according to traditional methods.

Meiringen, a pretty little town 20 km (10½ miles) from Brienz, on the upper banks of the Aare (Haslital), is popular with excursionists and alpinists. Fires in the 19th century destroyed most of the historic buildings, but some wooden constructions typical of the region were saved.

While you're in the area, you should try to see the deep **Aare Gorges** (*Aareschlucht*), a striking natural attraction at the foot of the Susten and Grimsel mountain passes. Assiduous readers of Sir Arthur Conan Doyle won't want to miss the nearby **Reichenbach Falls**, reached by funicular; it is here that Sherlock Holmes and his arch-enemy Moriarty plunged together to their deaths. The famous detective had to be resuscitated, under pressure by readers hungry for new adventures.

LUCERNE AND CENTRAL SWITZERLAND

Here, you are in the land of William Tell, at the heart of the country —a heart that is not only historical, but also geographical. Travelers have been attracted to this lush region since long before the age of tourism. This region includes the cantons of Lucerne, Zug, Uri, Nidwalden, and Obwalden.

Lucerne

Just about all the elements of a perfect tourist town converge in Lucerne (*Luzern* in German): a splendid waterfront setting against a backdrop of mountains; historic churches, interesting shops, and plenty of greenery; an annual music festival; and paddle-wheel excursion boats.

A thousand years ago, Lucerne was a humble fishing village that happened also to be home to a Benedictine monastery. Under the domination of the powerful Alsatian Abbey of Murbach, it became a merchant city; its importance increased with the opening of the Saint Gotthard pilgrimage route. Citizens of Lucerne enjoyed relative freedom until 1291, the year the Hapsburgs took the city. To release itself from their control, Lucerne turned in 1332 to the young Swiss Confederation. After the victory of the Confederates at the battles of Sempach in 1386, Lucerne, now independent, went through a period of prosperity. A Catholic bastion, it remained resistant to the Reformation.

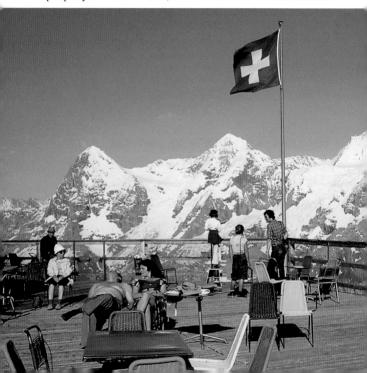

By the 18th century, Lucerne was the biggest town in the country and also the powerful center of Catholic Switzerland. In 1847, while the Catholic cantons were seceding (see page 21), Lucerne placed itself at the head of the rebellion. After the reconciliation, ornate grand hotels were built along the lake; in 1870, the legendary Caesar Ritz opened the Grand National Hotel. Alexander Dumas defined Lucerne as "a pearl in the world's most beautiful oyster."

> Three of the mightiest: sightseers take in (from left to right) Eiger, Mönch, and Jungfrau peaks.

The Old Town

The very model of the Swiss covered bridge, the Kapellbrücke (Chapel Bridge), a symbol of Lucerne, was built at the beginning of the 14th century over the Reuss River. It burned down in 1993—an emotional shock for Lucerners—and was reopened on 14 April 1994. Over a hundred 17th-century paintings adorn the triangles formed by its ceiling beams: they tell the story of the patron saints of the city and of the heroes of Lucerne, as well as some episodes from Swiss history. The bridge can only be crossed on foot. The octagonal stone tower alongside it, the Wasserturm (Water Tower) was used, up until the 19th century, as a prison, an archival library, and a treasury.

A little further along the left bank of the river, the **Jesuitenkirche** (Jesuit Church), begun at the end of the 17th century, is one of the oldest and most beautiful Baroque buildings in Switzerland. Its pink and white interior, decorated with stucco and frescoes, dates from 1750; the towers are from 1893.

Follow the Bahnhofstrasse away from the banks of the Reuss to reach the **Franziskanerkirche** (Franciscan Church), built in the 13th century in the Gothic style.

Return to the river and follow its course past the Zeughaus, the old arsenal, to cross the **Spreuerbrücke** (Mill Bridge). This covered wooden bridge from the beginning of the 15th century is decorated with superb paintings done between 1625 and 1632. Their theme, a common one in the Middle Ages, is the dance of death.

On the right bank, you enter the most striking part of the city: the **Weinmarkt** (Winemarket Square), the heart of medieval Lucerne. Most of the buildings that encircle it—old guild houses, boutiques, and patrician homes—have preserved their elaborately painted

Lucerne's 14th-century covered bridge is a picturesque landmark and favored postcard subject.

façades. Particularly worth notice is the Weinmarktapotheke (Winemarket Pharmacy), built in 1530.

Nearby, the **Hirschenplatz** (Deer Square), also surrounded by old houses, used to host the city's hog market.

The houses of the nobility around the **Rathaus** (Town Hall) are joined by several floors of arcades. One of these houses, the beautiful **Haus Am Rhyn**, at Furrengasse 21, is home to a fascinating collection of Picasso's late works. This museum also owns 200 photos of the painter by the photographer David Douglas Duncan.

Turning from the Reuss, walk up to the **Museggmauer**, part of the longest (870 m/2,854 ft) and best-preserved fortifications in Europe. From May to October, a section of these 600-year-old ramparts and three of its towers are open to the public. On the **Zyt Tower**, the oldest clock in town (from 1535) tolls one minute before every hour.

A short walk takes you past the Museumplatz and the Löwenplatz to **Löwendenkmal** (the Lion monument). What Mark Twain called "the most lugubrious and moving block of stone on earth" is dedicated to the memory of 800 Swiss mercenaries who died during the French Revolution, in particular in the Tuileries on 10 August 1792, while defending King Louis XVI and his family. This lion, mortally wounded with a blow of the lance, was carved in stone in 1821, after a drawing by the Danish sculptor Bertel Thorvaldsen.

Alongside the lion, you can see the "giants' tureens" in the **Gletschergarten** (Glacier Garden), deep holes sculpted 20,000 years ago by the glacier that covered this region. To better understand this geological phenomenon, go to the park museum, where fossils and minerals are on display.

The **Bourbaki Panorama**, a gigantic round painting illustrating the turning back of French troops commanded by General Bourbaki after their defeat at the hands of the Prussians (January 1871), is closed for renovation until February 2000.

In an attempt to prove that they don't live in the past, the Lucerners have chosen for their new **Center of Culture and Symposia** the

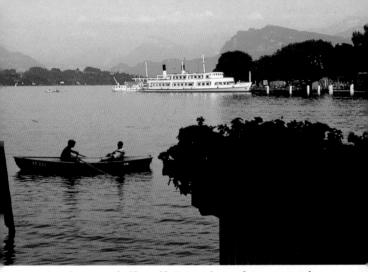

A cruise across the Vierwaldstättersee is a perfect way to get the feel of central Switzerland.

futuristic project of the famous architect Jean Nouvel, located between the train station and the pier. The concert hall has already been unveiled; the rest of the center will open in 2000.

The Verkehrshaus der Schweiz (Swiss Transport Museum), which is always being embellished and updated to keep up with technological progress, is the largest and most complete of its kind in Europe. The aeronautical section has dozens of early airplanes, as well as a reconstitution of the Zurich airport control tower, space capsules from the first American space flights, and even a moon rock. The Cosmorama has been recently renovated and reopened in mid-1999. The planetarium is also worth a visit. In the huge section devoted to railway transport, you can find more than sixty real locomotives and a very faithful reproduction of a section

of the Saint-Gotthard rail line. Swissorama, projected on a circular screen, shows a 20-minute film on Switzerland, its culture, traditions, and economy. The history of the automobile has its place here as well, as do tourism, the postal and telecommunications industry, and navigation by river, lake, and sea—for, land-locked as it may be, Switzerland is nonetheless a maritime nation. Finally, the museum also includes a giant-screen IMAX cinema which shows several different films each year on the subjects of nature and communications.

The **Richard Wagner Museum** occupies the spacious home where the composer lived from 1866–1872. It was in this house that he married Cosima, Franz Lizst's daughter. The villa, built on a promontory and commanding a wonderful view, was so dear to

This riverside café is most likely so popular for its view of the Baroque Jesuitenkirche.

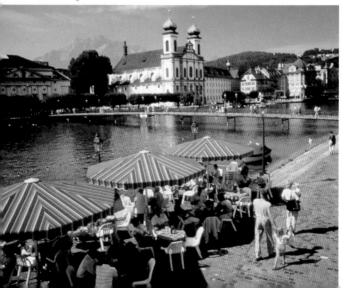

Wagner that he declared: "Nothing will make me leave this place." He was, of course, to leave it for Bayreuth...

The first floor has a selection of original scores, letters, and photographs, along with Wagner's grand piano. Upstairs is the city's collection of antique and exotic instruments.

The Lake of Lucerne

The most delightful way to visit central Switzerland is to take a steamboat in summer—a motorboat in winter—and to drift down the **Vierwaldstättersee** (the Lake of the Four Forest Cantons).

The softly sloping banks of the Swiss plateau, with Mount Pilatus (2,129 m/6,985 ft; see page 82) in the background, give way little by little to the foothills of the lower Alps and their pastures, while the higher peaks tower majestically over the south end of the lake.

There are many different itineraries, depending on the weather, the season, and how much time you have to spend.

The bay of **Kussnacht** is known for its flowering orchards and pointy-roofed farms. **Weggis**, **Witznau**, and **Beckenried** are pretty villages that invite you to wander or sit down for a nice meal.

Across from Weggis, above the lake, **Bürgenstock**, once one of Europe's most famous ski resorts, still attracts a fashionable clientele. A fascinating one-hour walk brings you to the foot of the impressive Hammetschwand elevator, which gives access to a fabulous view.

The 28-m (92-ft) rock that rises from the water on the other side of the lake from **Brunnen** is called the Schillerstein. This "pebble" is dedicated to the great German dramatist, Schiller, who immortalized William Tell (see page 22) in a famous play. Oddly enough, Schiller never set foot in Switzerland.

A bit further along, the meadow of **Rütli** is the symbol of Swiss national unity: the birthplace of the Confederation, founded here in 1291 (see page 15), it is also the place chosen by General Henri Guisan, in 1940, to gather his top officers to organize a national defense strategy.

81

The "Uri Lake" with its steep, fjord-like banks, is the wildest branch of the Vierwaldstättersee. While this entire region is particularly well-suited to hiking (as detailed in the brochures available in tourist offices, hotels, boats, etc.), the "Swiss road" along the banks of Lake Uri is nothing less than a historical adventure for those who love to walk. Most places here are also accessible by other means (train, boat, or bus). The **Tellskapelle** (chapel of Tell), on the east bank, is built on the very spot where William Tell is said to have leapt from the boat taking him to prison, thus escaping his jailers.

Flüelen, at the far end of the lake, was once the unloading dock for boats carrying merchandise destined for trade in Italy. The bundles were then loaded onto mules for the journey through the Gotthard pass. Altdorf, the county seat of the canton of Uri, owes its fame to William Tell, who shot the apple off his son's head here; at the Tellspielhaus, Schiller's play continually re-enacts the same victory.

Three Mountains

Mount Pilatus. Considered the emblem of Lucerne, it was scaled for the first time in the 16th century. This was a courageous undertaking, not only because it required good mountain-climbing skills, but because the villagers, believing the mountain to be haunted by the demonic spirit of Pontius Pilate (hence the name), forbade access to it with threat of imprisonment. When the lake where the evil spirit was said to reside was drained, Mount Pilatus fortunately lost its sinister reputation.

Generally, visitors take the boat or the train to Alpnachstad, then the cog-wheel railway (the steepest route in the world, with a 48° grade; it runs only in summer) which leaves you with a five-minute walk to the top (2,132 m/6,995 ft), where the view is extensive. To go back down, try changing your itinerary; take the cable car from Kriens.

Mount Rigi. In good weather, there is a superb view from Rigi-Kulm (1,800 m/5,906 ft) of the highest peaks of the Alps from Bern to the Valais. This "island in the sun" is accessible by cog train (from Vitznau or Goldau) or cable car (from Weggis).

Mount Titlis. Nearly twice as high as Rigi, it reaches 3,239 m (10,627 ft). First, go to **Engelberg**, a sunny ski resort beloved by sports lovers; its Benedictine monastery was founded in the 17th century. Be sure to admire the abbey's Baroque church; the organ here is the largest in the country. From the station, take the funicular, then the spectacular revolving cable car, to arrive at Klein (Little) Titlis, where the snow never melts; here, you can explore an ice cave and marvel at the peaks of Oberland and the Valais Alps. From here, it takes an hour by foot to cover the last 219 m (719 ft) of uneven terrain to the very top of Mount Titlis.

East of Lucerne

Whether they like it or not, statistics reveal that the citizens of Zug are the richest inhabitants of Switzerland. In international economy and finance circles, Zug is known as a fiscal paradise, which explains the presence here of so many business firms and sumptuous villas.

Small, cosmopolitan, and opulent, the town of **Zug** (*Zoug*) owes its charm to its ancient and perfectly preserved stone walls. Modern buildings blend with historic ones in a harmonious and original way. The Fischmarkt (the fish market), the Untergasse, and the Obergasse all evoke the Middle Ages. At the corner of the Fischmarkt and the Untergasse, the **Rathaus** (Town Hall) is remarkable for its magnificent Council Room. Among the vestiges of medieval fortifications, notice in particular the **Zytturm** (clock tower) on the Kolinplatz (ask for the key at the police station next door).

Just steps away, the 15th- and 16th-century **Sankt-Oswalds-Kirche** (Saint Oswald's Church) deserves to be seen for the delicate sculptures above its main door. Be sure to continue your visit just behind this church to the exquisite **Burg**, which houses an historical museum.

For a city that gave its name to the whole country, Schywz is rather placid, and much smaller than you might imagine. The

Bundesbriefmuseum, newly renovated, contains precious documents from the earliest days of the Confederation: the Pact of 1291, initialed by the representatives of the thirteen original cantons (see page 15), and a series of charters, each marking a stage in the fascinating construction of the country.

A half-hour from Schwyz, in the Muotatal, the **Hölloch** is a natural wonder: with an area of more than 175 km (109 miles) documented to date, this cave is one of the world's longest. There are several different tours available, in summer as well as winter, but research them well before you travel: depending on the season, trips may be organized according to demand.

Einsiedeln, one hour from Lucerne or Zurich, is an important pilgrimage site. Gigantic and imposing, its **Benedictine abbey** attracts many tourists.

The history of Einsiedeln began more than 1,100 years ago when a monk, Meinrad, was assassinated in his hermitage in the middle of the forest. A century later, he had become the object of cult worship, and some monks founded a monastery in his memory on the same site.

The church and its surrounding buildings, Baroque monuments of the 17th century, are considered the crowning achievement of their architect, Caspar Moosbrugger, a converted monk who lived in Einsiedeln for more than 40 years. At the center of the complex is the abbatial church, flanked by two towers. The church suffered bomb damage during the war, but its façade was recently restored. The goldand-white interior is by the Asam brothers of Munich; Cosmas Damian painted the frescoes and Egid Quirin executed the stucco-work.

In the chapel built on the spot where Meinrad was killed is a small Black Madonna; pilgrims come here in the hope that she will grant their prayers. Gregorian chants sung by the monks, along with frequent organ concerts, make this an unforgettable visit.

Cross-country competitors glide by in the ski marathon that takes place in Engadine.

The **Fürstensaal** (Hall of Princes) is richly appointed, a reminder that before the 15th century the abbots of Einsiedeln were princes of the German empire.

Today, Einsiedeln is a self-sufficient community of a hundred or so monks and around fifty lay brothers; they work at various trades ranging from mechanic to stonemason to baker. The monastery also operates a printing works, a stud farm, and a cattle farm.

THE GRISONS

This canton beats three records: it is the biggest, the least populous, and the most polyglot in all Switzerland. It is, in fact, the only canton where three languages are spoken: German (60%), Romansh (22%), and Italian (13%). The Grisons (*Graubünden, Grischuns, Grigioni*) occupy about one-sixth of the area of the country. This canton's most precious resource is the rough natural beauty it offers to visitors. Its history is closely linked to that of its ten mountain passes. Even today, several of them remain major arteries of European communication.

The first settlers to leave their mark here were the Rhaetians, a tribe whose descendants still speak the Romansh language. In A.D. 15, the Romans, seeking control over the mountain passes, conquered the Rhaetians. Later, the German emperors took it over for the same reason, imposing a feudal system on the area for centuries.

In the 15th century, the peasants organized themselves in associations like the Gray League (Grauer Bund), which gave its name to the Grison mountain range. They threw off the yoke of the foreign princes and the Church. External pressure united these solid mountain folk, but they could not stay independent forever. In 1803, after Napoleon's Act of Mediation, they joined the Confederation.

Chur

The gateway to the region, Chur (*Coire*) is also the cantonal capital and main crossroads. Westward, you can climb, by way of Flims, to the source of the Rhine; to the south, through the Julier or Albula passes, you can reach St. Moritz and other famous ski resorts of the Engadine; and to the east, there are Davos and Klosters. To get from one valley to the next, you have your choice between car, postal bus, and Rhätische Bahn, the regional narrow-gauge train.

Chur is an active little town. You will love visiting its ancient winding streets and its oddly shaped town squares. To guide you in your wanderings, the local tourist office has organized two walks, marked in an original fashion: just follow the red or green footprints painted on the ground. Both routes leave from the Postplatz and take, respectively, 60 and 75 minutes. In the Poststrasse, the medieval Rathaus (Town Hall) has a lovely courtyard and several beautiful rooms.

To reach the episcopal palace, the **Bischöfliches Schloss**, take the stone staircase up the hill past the medieval gates. This palace was reconstructed in the Baroque period and has remained the seat of the bishopric since the Middle Ages. Before you looms the half-Romanesque, half-Gothic **cathedral**, majestic despite its irregular layout (the choir is too high and its axis is misaligned with that of the nave). An immense triptych in gilded woodwork crowns the altar. The treasury, one of the richest in Switzerland, contains many venerable reliquaries.

A fine 17th-century building houses the historical and folklore collections of the **Rhätisches Museum** (Rhetic Museum). The **Kunstmuseum** (Fine Arts Museum), at Grabenstrasse 10, displays works from the 18th to the 20th centuries by Grison artists (Giovanni, Augusto and Alberto Giacometti, and Angelika Kauffman).

If you'd like an evening drink in a very unusual place, the Giger Bar awaits. It was decorated by H. R. Giger, who designed the film *Alien*—for which he won an Oscar.

Maienfeld (20 minutes away by car) is a charming village with some attractive bourgeois homes. An excellent red wine is made here, dry and light, and there is no shortage of inns at which to taste it. This is also the land of *Heidi*, the famous heroine of the children's book by Johanna Spyri.

Fishing is another sporting pastime many indulge in while visiting the Engadine.

After visiting Chur, you will find yourself within easy reach of several famous Grison resorts:

Lenzerheide-Valbella (1,500 m/4,921 ft) draws visitors year round. **Arosa** (1,740 m/5,709 ft) is a charming spot surrounded with wooded mountains reflected in two small lakes. Sports enthusiasts and romantics will both find what they want here.

As for **Davos** (1,560 m/5,118 ft), its international renown has grown now that it welcomes the World Economic Forum each year. But its pull is not only recent. Thomas Mann made it the setting of his novel *The Magic Mountain*. Numerous sports facilities and a huge ski area, shared with **Klosters** (1,180 m/3,871 ft), make this place a jewel not to be missed.

The Vorderrhein

A picturesque route follows the course of the Vorderrhein (upper Rhine) to its source, near Oberalp pass, on the way to Andermatt and Saint-Gotthard.

At **Reichenau**, you enter into the lush green valley of the Vorderrhein, wher the Upper and Lower Rhine unite to form the single great river that flows through Germany and Holland to the North Sea.

Past this small city, the valley narrows and the route rises to the sunny ski town of **Flims** (1,080 m/3,543 ft), made up of two parts, Flims-Dorf and Flims-Waldhaus; the latter is where you will find the hotels, scattered through a dense forest of pines and larch, interspersed with sparkling lakes. Below Flims is **Laax**, a much smaller town with an interesting Baroque church from the end of the 17th century. **Ilanz** proudly calls itself the first city on the Rhine, basing its claims on 1,200 years of history. In **Trun**, visit the impressive 17th-century residence of the abbots of Disentis (now a museum of local art and folklore).

In **Disentis**, the great 12th-century abbey testifies to the importance of this town as a religious center in the Middle Ages. The current monastery dates from the 17th century, while the Baroque abbey church (*Klosterkirche*) was built over the tomb of Sigisbert, the hermit-monk, in the 18th century.

The Hinterrhein

To reach the Ticino, you can go through the Hinterrheintal, or valley of the lower Rhine, in the direction of the San Bernardino pass.

After the Domleschg valley, with its villages and castles, you drive past Thusis to the Via Mala: harsh and arid, this "canyon" carved out by the frothing Rhine is now perfectly accessible.

The "bad way" (via mala) opens out onto the Schams (or Schons) valley. The jewel of this region is Zillis, where a 12th-century church harbors the oldest painted ceiling in Europe. The 153 panels of St. Martin's church were inspired by the New Testament and the lives of Christ and St. Martin.

After the endearing village of Andeer, you enter the Rheinwald. Splügen, a town favored by hikers, is also a crossroads: on one side, the Splügen pass leads to Italy; on the other, the San Bernardino pass (or the tunnel of the same name) is the gateway to the Ticino.

The Engadine

In the valley of the River Inn (or En), which gives Engadine its name, the contrast between the ancient villages and the ultramodern resorts is striking. The former are made up of sturdy stone houses with their unique sgraffiti decorations. This technique consists in covering a dark stucco wall with a white coating, which is then scratched in places to reveal the layer beneath.

The Engadine is divided into two regions, lower and upper. The first stretches from Maloja to Zernez. From Chur, you can reach it through the Julier or Albula passes. Lower Engadine extends from Zernez to Martina, on the Austrian border; from Davos or Klosters, you can get here through the Flüela pass.

Guarda, in lower Engadine, has preserved its tiny paved streets, its fountains, and its intricately worked houses. If you are curious about local architecture and folklore, be sure to make a stop here.

Another very pretty village is Scuol (Schuls, in German), the last stop on the Rhätische Bahn. This dynamic little town, like its neighbors Tarasp and Vulpera, has its own thermal baths.

On the border between lower and upper Engadine, Zernez is the main gateway to the Swiss National Park. Begin with a visit to the

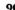

Park House, where you can get all the information you need and also watch an audiovisual presentation on the park. The Park itself is small (160 sq km/100 sq miles) but very well preserved: you could forget about the human race here, if not for the signs indicating (very clearly) the paths for forest walks. The best time to visit is from mid-June to the end of October. The flora is particularly var-

There are breathtaking views to be seen at every angle in the upper Engadine region.

ied because of the very hilly terrain, and you may catch a glimpse of such unusual animals as ibex, stag, deer, and marmots.

The Ofen pass (Fuorn pass/Pass dal Fuorn), just past the park, takes you to **Müstair** ("monastery" in Romansh), the main village of the wooded valley of the same name, situated at the Italian border. During the Reformation, the towns of the region converted to Protestantism, but Müstair, barricaded behind the walls of its monastery, remained Catholic. Here, Romansh is king.

At the end of the village, the **Abbey of Saint John the Baptist** was founded in the eighth century by a bishop of Chur who was related to Charlemagne. (Tradition has it that Charlemagne himself was responsible for its foundation.) The church, with its triple apse, underwent transformations in the 15th century. The wall paintings are some of the finest remaining examples of the Carolingian period (the first half of the ninth century). Also, note the 12th-century statue of Charlemagne.

Back in the Inn valley, stop at **Zuoz**, a quaint, well-preserved town. It has a church with windows by Giacometti and a group of typical Engadine houses around the main square that date from the 16th to 18th centuries.

St. Moritz, a world-renowned ski resort, attracts a rich and cosmopolitan clientele. The success of St. Moritz—which prides itself on being the birthplace of Alpine winter sports (1884)—is justified by its favored natural setting, dry and sunny climate, elaborate recreational facilities, and a carefully maintained reputation for elegance. The paradise of snow sports, this region offers infinite possibilities. Its bobsled and skeleton slopes are very famous. The village is roughly divided in two parts: St. Moritz-Bad, where the thermal baths are located, and, on the hill, St. Moritz-Dorf, with its palatial hotels.

Worthy of note are two museums: the **Engadine Museum** (furniture, tile stoves, and historic weapons through the ages) and the **Segantini Museum** (landscapes by the Italian painter Giovanni Segantini, inspired by views of the Engadine region.) Northeast of St. Moritz, ride the funicular to **Muottas Muragl**, a panoramic vista point from which you can survey all of the upper Engadine. See if you can spot Pontresina, the lakes of St. Moritz and Silvaplana, and Sils (where Nietzsche stayed while writing *Thus Spoke Zarathustra*). Even further out is the Maloja pass. Or, climb even higher to the Piz Nair (3,057 m/10,030 ft), reachable by funicular, then cable car, and finally by foot (15 minutes).

There's no excuse for missing the Glacier Express that ties St. Moritz to Zermatt. This seven-and-a-half-hour trip across the Alps, ending at the Oberalp pass, is spellbinding. Panoramic windows in each train car offer an exciting spectacle both in winter and in summer. The train goes through 91 tunnels, crosses 291 bridges, and takes hairpin turns that will leave you with goosebumps.

Pontresina (1,803 m/5,915 ft), on the Bernina Pass road, has some beautiful ski slopes. A base for alpinists—you'll find the largest climbing school in Switzerland here—it offers hiking trails as well. The glacier trail at Morteratsch has signs explaining the formation of moraines, deposits of earth and stone left by moving glaciers.

Whether you go through Bernina pass in a car, a train, or a bus, you will never forget the sights afforded by this route into the Poschiavo Valley: the Morteratsch glacier, the **Diavolezza** panorama, the Piz Palü, and, on the other side of the pass, the Alpine garden of Alp Grüm. In this valley, Italian is spoken; in fact, all over Poschiavo, you can sense the Mediterranean atmosphere.

THE TICINO

When you arrive in the Ticino from the Grisons, from Uri or from Valais, you suddenly find yourself surrounded by Italian cnversation, music, and food, backing in a sunny and charming atmosphere that seems to have been lifted straight out of neighboring Italy.

Tourists flock here, drawn by the picturesque villages and lakes, the deep valleys that seem to plunge into another age, the many cultural offerings, and the opportunity to practice almost any sport.

St. Moritz is a town of much natural beauty—and of more material pleasures as well.

The Ticino is closer to Milan than it is to Bern, and its ties to Italy are very strong, especially the cultural ones. The Ticino was torn from the Milanese by the Swiss in the 15th century and dominated by the cantons on the other side of the Gotthard pass until 1803, when it was made a canton of its own. This attachment to the Confederation is all the more remarkable given that, until the end of the last century—that is, until the construction of the Gotthard railway tunnel (the highway tunnel wasn't finished until 1980)—the canton spent every winter cut off from the rest of Switzerland.

Bellinzona

The capital of the Ticino, Bellinzona guards the way to three mountain passes—Saint-Gotthard, Lukmaier, and San Bernardinowhich explains the town's turbulent history. It was a coveted location indeed, fought over by the Romans, the Franks, the Lombards, and the Swiss of the Confederation.

Beautiful Lombard-style arches, pastel-colored houses with balconies, and old churches make up the heart of Bellinzona. Not to be missed are the three medieval castles surrounded by **crenellated walls**.

The **Castel Grande** or Castel Vecchio, dating originally from the fourth century A.D., has been creatively restored by the architect Aurelio Galfetti. This group of buildings includes a historical museum, theaters, and two restaurants. The second, the **Castello di Montebello**, was built from the 13th to the 15th century. It was restored in 1903 (exterior) and during the 1970s (interior). A museum of archeology and history, the Museo Civico, has been installed here: it displays pieces found in archeological digs all over the canton.

The third castle, which dwarfs the two others, is the 15th-century **Castello di Sasso Corbaro**. It was built in some six months of day and night labor by order of the Duke of Milan, who feared an imminent offensive by the Swiss.

Bellinzona's three fortresses are often called by their nicknames —Uri, Schwyz, and Unterwald—in memory of the baillifs sent by the *Waldstätten* in the 16th century to rule over the region.

Locarno and Lake Maggiore

West of Bellinzona, on Lake Maggiore, **Locarno** luxuriates in tropical vegetation: orange trees, banana trees, palms, and flowers all grow in abundance year-round.

The best known monument in Locarno is the **Madonna del Sasso**, 5 minutes from the center of town by funicular. For centuries, pilgrims have climbed the steep path to its sanctuary. The church, perched on a rocky cliff, seems immense from a distance, but this impression lessens upon entering, maybe because of the huge number of artworks housed inside it.

From here, hikers and, in winter, skiers can take the cable car up the steep flanks of Mount Cardada in just a few minutes. A ski lift takes you the rest of the way to the **Cimetta**, a superb belvedere, where the view of lake and city is breathtaking.

Once back "on land," those who love art and history should make it a point to visit the **Castello Visconti**, which was partially restored in the 1920s. The arch-lined 15th-century courtyard bears witness to the lost splendor of the castle's fortifications. Within the castle is the Museo Civico, a rich archeological collection with

Embellished exterior walls and windows add warmth and charm to this wintery Zuoz street scene.

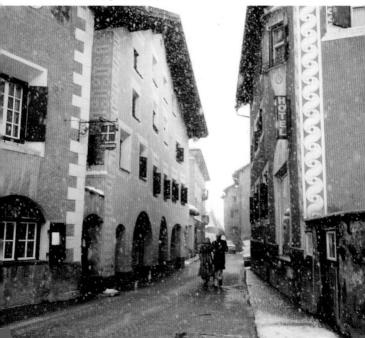

many relics that date as far back as the Roman Empire (open from April to October).

Follow the Via Rusca to the **Piazza Grande**, the main square of Locarno, lined with shops and cafés, which hosts the screenings and ceremonies of the **International Film Festival** each summer.

Up the hill, the **Città Vecchia** (Old Town) boasts an appealing combination of stately villas, time-worn tenements, hidden gardens, and venerable churches. The Casa Rusca, on the Piazza Sant Antonio, contains works from the collection of Jean Arp (who died in Locarno in 1966), a leading Surrealist and one of the founders of the Dadaist art movement, as well as other donations.

Lake Maggiore (*Lago Maggiore*), shared by Italy and Switzerland, tempts excursionists and lovers of water sports. The **Isles of Brissago** make a fun day trip. On San Pancrazio, the largest, is the Botanical Garden, devoted to exotic plants—bamboo, sugar cane, cactus—and all manner of citrus trees. Some boats continue toward Stresa to the Borromeo Islands, in Italian waters.

Ascona is separated from Locarno only by the mouth of the River Maggia. Once a simple fishing village, this little hamlet has long played host to artists and intellectuals: Isadora Duncan, Paul Klee, and Lenin all stayed here. Also contributing to its fame are the frequent art exhibitions it hosts and an annual classical music festival (*Settimane musicali*).

Along the lake, innumerable outdoor restaurants and cafés invite you to partake of the "*dolce far niente*." Along the narrow cobblestone streets, many of the older houses have been converted into fashionable and appealing boutiques. The city also has some interesting churches, like Santa Maria della Misericordia, with its wonderful late-Gothic frescoes.

On the **Monte Verità**, there are no less than three museums retracing the history of this spot where, between the end of the 19th century and the early decades of the 20th, so many thinkers, dreamers, and reformers lived and crossed paths. The museums are closed

in winter. **The Communal Museum of Modern Art** is quite rich, thanks to donations from foundations and from the artists who chose to live here in those years.

If you want to breathe some country air, head for **Ronco**, a picturesque town on the lake, about 2 km (1 mile) to the west. From Locarno or Ascona, a day trip is enough to explore the surrounding high, isolated valleys. Hearty types can attack them by bike or on foot (maps are available in tourist offices around the region); the less ambitious, by car or postal bus. The wild and magnificent **Val Verzasca**, will not fail to move you. The most remote village, **Sonogno**, is only 31 km (19 miles) from Locarno, but the contrast between it and the luxurious prosperity of the lakeside couldn't be more striking. The simple houses of Sonogno are entirely constructed of dry stones balanced one on another without any mortar.

The Valle Maggia follows the meandering River Maggia, northeast of Ascona and Locarno. Italianate architecture in all its variations is universal here—until you reach the wooden chalets of the remote village of **Bosco** (*Gurin*), in a side valley settled in the 12th century by emigrants from the canton of Valais. Their descendants still speak an obscure Swiss-German dialect that is unique in the Ticino.

The **Centovalli**, which links Locarno with Domodossola, is charmingly twisty, while the Onsernone valley is rough, but authentic.

Lugano and Its Lake

First town of the Ticino, **Lugano** sweeps down between two mountains and slopes softly to a shaded lakefront promenade. Yachts and boats ply the lake with its wooded banks. Pleasant villages cling to the jagged outcroppings around the lake.

Here, the sun shines for over 2,000 hours each year. Forsythias and mimosas blossom in February; March is the time for camellias, magnolias, and peach trees; while April glows with azaleas, rhododendrons, wisteria, and Japanese cherry trees in bloom. The main square, **Piazza della Riforma**, is a vast space devoted to row upon row of café tables; you can linger here indefinitely, sipping an espresso or an aperitif. Covered shopping streets filled with boutiques lead from the plaza into the old town.

Facing the lake at the southern end of the via Nassa is the tiny church of **Santa Maria degli Angioli** (Saint Mary of the Angels), with the finest Renaissance frescoes in the Ticino. The most famous cycle, painted at the beginning of the 16th century, is a luminous *Passion of Christ* by Bernardino Luini, a student of Leonardo da Vinci; the same artist also decorated one of the side chapels.

In the lakeside park opposite the church, there are many modern sculptures that can be enjoyed during a short stroll.

On the hill halfway between the lake and the train station, **San Lorenzo** is famed for its sumptuous Renaissance façade.

No art lover will want to miss the art gallery of the **Villa Favorita**. The residence of Baron von Thyssen-Bornemizsa was built

Modern Architecture

Lugano, like Bellinzona, Locarno, and other cities in the Ticino, has many examples of modern architecture. In fact, since the end of the 1960s, the Ticino has seen the development of several generations of talented architects, whose international renown has inspired local authorities to invest in sizable architectural undertakings. (A detailed and interesting history of this phenomenon, entitled "Discovering Modern Architecture in the Ticino," is available at tourist offices throughout the canton.) Examples include a series of creations by Mario Botta: the Banca del Gottardo (1988, viale Stefano Franscini), the Palazzo Telecom (1997 in Bellinzona), and the Palazzo Botta (1991, via Ciani 16, Lugano). Also worthy of note are the Architect's Studio (1994 in Mendrisio) by Ivano Gianola and the Palazzo delle Poste (1996 in Locarno) by Livio Vacchini.

99

in the 17th century in Castagnola, east of the city, in a park on the lake. The Baron's collection of paintings and sculptures, considered one of the greatest private collections in Europe, is open to the public (but only during selected hours—ask at the local tourist office). Currently, 19th- and 20th-century European and American oils and watercolors are on display, along with ten lithographs by Toulouse-Lautrec. A series of sculptures dating from the 15th to the 17th centuries completes the show.

The Villa Malpensata, a modern art museum, offers a permanent collection of artworks from the Ticino along with several very well-

known names; top-caliber temporary exhibitions come through as well, attracting huge crowds. The **Cantonal Art Museum**, occupying three buildings built between the 15th and 19th centuries, also hosts exhibitions by contemporary artists in addition to its permanent collection.

An enthusiastic journalist once called Lugano "the Rio of Europe." For him, Mount San Salvatore was nothing less than a little brother of the Sugarloaf. To see if he was right, take a look—the best view is from **Mount Brè** (accessible by funicular). San Salvatore itself (912 m/2.992 ft) can be reached

Lugano is known—and rightly so—for its parks and gardens filled with seasonal blooms.

by funicular as well, for fabulous views and pleasant hiking trails back to the city.

A cruise on the lake will let you marvel at the peaks surrounding it and to see, or stop and visit, some quaint villages.

Gandria. Many artists have been attracted to this fishing village covered in flowers, yet Gandria, located northeast of Lugano, has never lost its authenticity. In the little town across the river, the Museo doganale svizzero (Swiss Customs Museum), best reached by boat direct from Lugano. Anyone who has ever sneaked a bottle of perfume past a customs guard will be interested in studying the

display of ingenious hiding-places used by professional smugglers —all nabbed by Swiss customs officers, of course.

Melide, south of Lugano, can be reached by land or water. Since 1959, millions have come to this village to lose themselves in the labyrinthine world of **Swissminiatur** (open from mid-March to mid-October), a model (built to 1:25 scale) of more than 100 national monuments. Trains slide on their tracks through tunnels and mountains, funiculars scale the peaks, and boats drift by... the exhibition is fascinating and complete down to the last detail.

Morcote is an adorable village nestled into a hill. A long stone staircase from the 17th century takes you up a steep slope to the medieval chapel of Saint-Antoine. Further up, an slender belltower marks the **church of Santa Maria del Sasso** and its cemetery, full of towering cypress trees.

After Capolago, the southernmost of the Swiss ports, a cog-wheel railway chugs up the **Monte Generoso** (1,701 m/5,580 ft). At the top, the terrace offers a one-of-a-kind view onto the Lombardy plateau, over lakes, the hills of the Ticino, and the Alpine peaks to the north.

Not far from Capolago, **Riva San Vitale** has two monuments that are worth seeing: a **baptistery** from the mid-sixth century, the oldest Christian building in Switzerland, and **Santa Croce**, a 16thcentury church in the Renaissance style, recognizable by its impressive cupola.

On the other side of the lake from Lugano is **Campione d'Italia**, which is just what its name implies—an Italian enclave in Swiss territory. The border is now only virtual, and it's fun to note the signs of this discreet mixture between the two countries. Campione is known for its imposing casino, built by Mussolini in 1933.

THE VALAIS

Since prehistoric times, the long, wide, untamed valley that bears the name of the Valais (*Wallis* in German) has been an important means of communication between northern and southern as well as eastern and western Europe. The lifeline is the River Rhone, which flows from the Rhone Glacier to the shore of Lake Geneva. On either side soar some of the highest peaks in the Alps.

Here, nature defies the imagination: waterfalls drop down the sheerest of cliffs while glaciers blind you with their whiteness. There are orchards in full bloom, rugged vineyards, mythic summits, and cowbells tinkling in the mountain pastures.

The mountains on the right bank protect the valley against cold winds and, often, rain, while the orientation of the side valleys to the *föhn* (a characteristic warm, dry wind) gives the region a gentle climate.

Each of the adjacent valleys has its own customs and traditions. Halfway into the Valais, somewhere around Sierre, the French language suddenly gives way to Swiss-German. But the linguistic division and cultural diversity of this canton doesn't seem to prevent the cohesion of its inhabitants, who are united by a strong Catholic faith.

After its domination by the Romans, the Valais was controlled by the Burgundians. In the 15th century, the Burgundian king bequeathed it to the bishops of Sion, whose influence made it impermeable to the Reformation. But there was no resisting the occupation by France after the Revolution in 1798. Made its own independent state by Bonaparte, the Valais became a French *département*—known as Simplon—before finally joining the Confederation in 1815.

We will survey the length of this valley, rich in churches and monasteries, from Saint-Maurice to the sources of the Rhone, losing ourselves from time to time in the valleys along the side.

The Lower Valais

Above Monthey, **Champéry** (1,050 m/3,445 ft) offers lovers of winter sports access to a huge ski domain, **Portes du Soleil**, which reaches all the way to France. In summer, more than 200 km (125 miles) of groomed slopes await the eager mountain biker.

Back in the main valley, stop at **Saint Maurice**, wedged between a precipitous cliff and a mountain range. The **Abbaye de Saint-Maurice** counts among the oldest monastic institutions in Christendom. For nearly fourteen centuries monks, and later canons, have been singing their psalms here. All this fervor commemorates Maurice, a Christian officer of the Roman Army who, because he had refused to worship the Roman gods, was massacred with his followers, some 6,000 men, around the year 285.

Since the fourth century, pilgrims (among them princes of Cristendom) have come to place their offerings on the martyrs' tombs. These accumulated gifts make up the **treasury**, which includes some exceptional pieces of silversmith work.

Martigny, located at a sharp angle along the Rhone riverbank, has long been an important crossroads. Its old city contains the ruins of a Roman amphitheater which could hold 6,000 spectators. On a fortification to the west stands the Bâtiaz, the stark tower (now restored) of a 13th-century castle. Finally, outside the center of town, an audacious architectural complex is home to the **Pierre-Gianadda Foundation**, which brings together a museum of Roman antiquities, an automobile museum, and a cultural center which organizes highquality temporary exhibitions (Gauguin, Modigliani, Picasso) as well as concerts and theatre programs. The park is full of admirable statues by Rodin, Brancusi, Miró, Moore, Dubuffet, and more.

Travelers hurrying to get across the Alps will take the tunnel (nearly 6 km/4 miles long) that connects Switzerland and Italy, thus avoiding the difficult road through the **Grand-Saint-Bernard** pass (2,469 m/8,100 ft high). The new road also sidesteps the famous **hospice** founded by Saint Bernard of Menthon. The historical museum, which recently burned down but was reconstructed and reopened in 1998, is full of artifacts from Napoleon's passage through the pass, in 1800, with 40,000 men on their way to the battle of Marengo. In the kennel, friendly St. Bernard dogs are raised and trained to rescue avalanche victims.

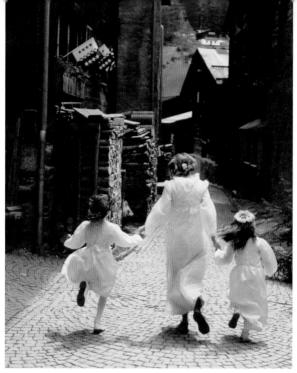

Valais village girls dressed in festive finery hurry over the cobblestones to the awaiting fête.

Sion

Nearly 1,000 years ago, when bishop-princes held sovereign authority over the whole of the Valais, Sion added a politico-religious role to its traditional military one. The most famous of its bishops, Cardinal Matthew Schiner (1465–1522), is still the hero of the canton, even though his schemes—he pushed the then-young Confederation

to ally itself with the pope, which sent it into war with the king of France—finally led to the defeat of the Swiss at Marignano.

Beginning with the "twin hills" that make up Sion: Tourbillon, the hill closest to the mountains, is crowned by the ruins of a 13th-century episcopal castle. **Valère**, closer to the river and the center of town, supports an imposing fortified church. This Romanesque-Gothic structure, once the cathedral of Sion, is known for its naïve stone carving, its 15th-century frescoes, and its choir stalls from the 17th century. The organ, constructed at the beginning of the tenth century, is one of the oldest functioning organs in Europe.

Between the hills, in Rue des Château, there are two more museums of interest: La Majorie, once the residence of church officials, now holds the Musée cantonal des beaux-arts (Cantonal Fine Arts Museum); and the modern Musée cantonal d'archéologie (Cantonal Museum of Archaeology), on the other side of the street, which brings together objects found at archeological digs all over the canton.

In the heart of town, you will see the 17th-century town hall, painted pink; the astronomical belfry clock is from 1667. The **cathedral** (Notre-Dame-du-Glarier), in late Gothic style, was built after a fire destroyed the original Romanesque edifice, whose belltower is all that remains.

Finally, you will reach the **Maison Supersaxo** (16th century), just off the street of the same name. Georgius Supersaxo (the Latin pseudonym of Jörg auf der Flüe) is a great figure in the history of the Valais region. He spent most of his life fighting Cardinal Schiner. Note the sculpted ceilings of the main hall.

Sion is a good starting point for day trips to neighboring ski resorts. To the north, **Crans-Montana** awaits you with its exceptional ski slopes; it also has facilities for tennis and golf, and various places to shop. Food-lovers will not be disappointed in the cuisine, and night-crawlers may run into vacationing celebrities. To the south, the **Val d'Herens** is known for its picturesque villages with dark wood chalets, generously hung with red geraniums in summer. **Evolène** is an authentic old village, and **Arolla** (2,000 m/6,562 ft), to the south, is a center for mountain climbing.

At the bottom of the Hérémence valley, the **Grande Dixence** dam is the highest in the world. The topmost ridge of the structure is 2,365 m (7,759 ft) high, offering a view that will truly take your breath away.

Continuing down the Rhone to the east, you will reach the last bastion of the French language, announced by a sign in two languages: **Sierre/Siders**. Surrounded by vineyards, the city enjoys a particularly dry climate. Taste vintage wines in any one of a number of cellars, or learn about viticultural techniques in the **Valaisian Museum of Wines and Winemaking**.

On a detour south of Sierre, nestled in the **Val d'Anniviers**, you'll find Chandolin, one of the highest European villages that is inhabited year round (1,934 m/6,345 ft), and a few other charming mountain resorts including St-Luc, Grimentz, and Zinal, which are all dwarfed by Mount Weisshorn (4,505 m/14,780 ft) and the Zinalrothorn (4,221 m/13,848 ft).

Past Sierre, in the Rhone valley, **Leuk** (*Loèche*) can be recognized by its castles and towers dating from the era of the "majors" (church officials of Sion). The road through the Gemmi Pass, leading to Kandersteg (Bernese Oberland), leaves from **Leukerbad** (*Loèche-les-Bains*), an upland spa and center for hiking and mountain climbing.

From Gampel, halfway between Sierre and Brig, a road leads steeply to **Lötschental**, a high, wild valley which was unreachable in winter for centuries. That is, until 1913, when the 15-km- (9-mile-) long rail tunnel that links the Valais to the Bernese Oberland was inagurated.

Pull over in **Kippel** and stroll around the church. The **Lötschentaler Museum** reveals the secrets of this mysterious valley.

Women wear the local costume to do everyday chores, such as working around the house.

The Upper Valais

The most famous mountain in the Valais, the **Matterhorn** (Mont Cervin; Monte Cervino: 4,478 m/14,690 ft) is, if not the highest in the Alps, certainly the most impressive. This formidable horn-shaped peak has never ceased to be a challenge to mountaineers the world over.

The first expedition to reach the top was led by a young Englishman, Edward Whymper. His team scaled the northeastern face of the mountain. But this victory, achieved on 14 July 1865, did little to dispel the terror that the Matterhorn has always inspired. On the contrary, it reinforced it; on coming back down, four of the seven victors suffered a fatal fall.

The **Alpine Museum** in **Zermatt** retraces the history of the conquest of the Matterhorn. This famous resort town has often served as a base for Alpine expeditions. From Visp (*Viège*) in the Rhone Valley, head up the Mattertal (37 km/23 miles) to arrive at this village, where cars are prohibited and sleds and carriages are the sole means of transportation. Zermatt offers the skier comfortable lodgings and snowy slopes year round. A cog-wheel railway will take you to **Gornergrat** (3,135 m/10,285 ft), with an unforgettable view of **Mount Rose**.

If you're not afraid of heights, take the four successive cable cars to the **Little Matterhorn**: the fourth, overlooking the glacier, deposits you at the highest ski resort in Europe (3,820 m/12,533 ft).

In a parallel valley nestles another famous resort, **Saas-Fee**, dominated by several mountains topping 4,000 m (13,100 ft). Cars are not permitted (you may park in special lots provided at the entrance). A subway links Fleskinn to Mittelalallin, 3,500 m (11,483 ft) up, where the **Ice Palace** awaits you. In a cave of over 5000 cubic m (16,400 cubic ft), you can discover the secrets of thousand-year-old glaciers.

Although the Swiss have mixed feelings toward Napoleon, **Brig** has nonetheless named one of its streets after the great man. He was the first to follow the Simplon pass road, which begins here, through the Alps.

This town is dominated by the three onion-shaped domes of the **Stockalper Castle**, built by Kaspar Jodok von Stockalper (1609–1691), a very wealthy businessman. In addition to several of the main rooms, the public is allowed to visit the chapel and a museum of the crafts and customs of the Valais.

The **Simplon pass** (2,005 m/6,578 ft), only 25 km (16 miles) away, is the high point of a spectacular road, all gorges and steep embankments, which winds its way into Italy.

At the furthest point of the Rhone Valley, which is called Goms Valley after the town of Fiesch, is the **Furka pass**. At 2,431 m (7,976 ft), it is a vital link between the east and the west of Switzerland, and boasts an incomparable view onto the peaks of the Bernese Oberland. Just before the pass, you can stop for a closeup look at the **Rhone glacier**, as impressive as any you'll see in Switzerland. The **ice cave** is open from June to October. The rail tunnel which goes under the Furka since 1982 has put an end to the isolation of the villages along the Goms.

VAUD AND LAKE GEVEVA

In this canton, the most populous in western Switzerland, French is spoken, mixed with with the rural dialect of the region. Two mountain ranges, the Alps and the Jura, surround Vaud, making its landscapes and climate vary widely. To the south, the Lake of Geneva (*Lac Léman*)—the largest of the Alpine lakes—has two-thirds of its waters in Swiss territory and the other third in France. Lake Geneva has always fascinated artists, poets, and composers. As peaceful as it seems most of the time, with its sailboats, steamers, and motorboats, its elegant swans and carefree ducks, this miniature ocean can unleash the occasional tempest throwing huge waves against the shores of the crescent-shaped lake.

In summer, vacationers and Vaud natives politely compete for space on the café terraces; small glasses of the local white wine are emptied as fast as they can be refilled.

La Côte

With a view across the Lake of Geneva to the French Alps, the villages of La Côte are dotted along the lakeshore from the edge of Geneva eastwards to the busy university and commercial city of Lausanne, a distance of 60 km (37½ miles). If you drive from town to town, take the lake road which parallels the water rather than the motorway further inland. Beyond Nyon begins the wine-growing region of La Côte. You can follow the signposted Route du Vignoble (Route of the Vineyards) up gently terraced hillsides. Some highlights along the coast:

Coppet evokes the memory of a great writer, Germaine Necker, better known as Madame de Staël. Her father, Jacques Necker, a Genevan banker who was named Director General of Finance under Louis XVI, acquired the **château** (today a museum) in 1784. When Madame de Staël fled Napoleon's Paris in 1803, she exiled herself to Coppet, where she surrounded herself with a court of her own: Benjamin Constant, Madame de Récamier, and Chateaubriand. One of her friends reported that "more wit is dispensed in one day at Coppet than in one year anywhere else in the world."

Deep in the heart of **Nyon** you'll find Roman ruins, a castle begun in the 12th century, a church from the same era, and a group of 15thto 19th-century houses.

The fire-towered **castle** of Nyon served as a military bastion for the dukes of Savoy, who expanded their domain from the other side of the lake. In the courtyard, a Romanesque mosaic recalls that Nyon was founded by Julius Caesar around 45 B.C. To get an idea of what medieval life was like in this small village, visit the historical museum inside the castle itself. Upstairs, another museum displays the famous Nyon porcelain from the end of the 18th and beginning of the 19th centuries.

Near the castle on the rue Maupertuis, the vestiges of a Roman basilica from the first century A.D. stand next to a small museum full of Roman objects discovered here and elsewhere in the region.

In April, Nyon welcomes the documentary film festival "Visions of the Real," while in July, during the **Paléo Festival**, a wave of musical madness descends on Nyon. This French-speaking Swiss Woodstock brings together many musical styles and trends, along with spectators of every horizon and nationality.

Rolle is endowed with a 13th-century castle on the banks of the lake. The inhabitants of Bern, who invaded the canton of Vaud in the 16th century, burned it down twice.

Morges makes its reputation in spring, when the annual Tulip Festival is held here. No less than 300,000 of these flowers are displayed in Independence Park, near the lake.

Before the construction of the railroad, Morges was an important port for the ferrymen of the lake. The imposing **castle** on the port was erected in the 13th century by Louis I of Savoy; it now contains the **Military Museum of Vaud**, displaying uniforms, flags, arms, and 8,000 tiny leaden soldiers.

In the Grand-Rue, the museum inside the 16th-century **Alexis Forel house** has a collection of furniture, porcelain, and glass, as well as antique dolls and toys.

Lausanne

There is always something happening in this prosperous city, capital of the canton of Vaud and headquarters of the International Olympic Committee (IOC). Cosmopolitan Lausanne's attractions include ballet (the Béjart company), classical music concerts, operas, jazz, theater, cinema (the Swiss cinemathèque), and fairs.

The history of *Lousonna* goes back to Roman times, when it was an important crossroads for trade. An episcopal city since the beginning of the 12th century, Lausanne grew in economic importance over the course of the Middle Ages. In 1537, the Academy (later to be a university) was created, giving this religious and commercial center an intellectual bent. Since 1874, Lausanne has been the seat of the Federal Tribunal, the highest judicial body in the Confederation.

Ouchy, on the banks of Lake Geneva, is the liveliest part of town, with its parks, cafés, restaurants, and château (now a hotel). From the port of Ouchy, large white steamers leave for Vevey, Montreux, Evian, Thonon, Morges, Nyon, and Geneva.

Skiers and sightseers float across blinding white skyline with a view of the Valais and the Bernese Alps.

A stone's throw from Ouchy, the Vidy Theater hosts productions (sometimes in their European premiere) by such well-known directors as Peter Brook and Robert Wilson.

To leave Ouchy for the Place Saint-François, a commercial square built around a 13th-century church, take what the locals call the *métro* or the *ficelle* (piece of string). From Saint-François, you can follow the boutique-lined rue de Bourg to the rue Caroline, before crossing the Bessières bridge. There is no need to describe the way to the **cathedral**; it is impossible to miss as it looms before you. Built in Burgundian Gothic style and finished in 1275, the cathedral retains some remarkable vestiges of the 13th century, including some lovely

choir stalls and a **rose window** in the transept. An ancient tradition is still observed in the sanctuary: every night, from 10pm to 2am, a crier announces the hours to the city from the top of the church tower.

The old episcopal palace, located next door to the cathedral, currently holds the **Musée historique de Lausanne** (historical museum of Lausanne). Temporary exhibitions are also shown here.

Covered staircases descend from the cathedral to the **Place de la Palud**, which has hosted an outdoor market since the Middle Ages (now held on Wednesday and Saturday mornings). This does not detract from the solemn dignity of Lausanne's 17th-century **Hôtel de Ville** (Town Hall), with its attractive ensemble of arches, clocktower, and gargoyles.

The town has a dozen or so museums devoted to subjects from the history of the Olympics to that of pipe-smokers. But the most original museum in Switzerland may be the **Collection of Primitive Art** (Art Brut), housed in a 13th-century castle, near the palace of Beaulieu. This dazzling collection of naïve creations was founded by the artist Jean Dubuffet.

North of Lausanne is the **Hermitage Foundation**, with a view of the lake and the historic town center, which hosts temporary painting exhibitions.

The **Musée de l'Elysée** (avenue de l'Elysée 18) occupies an appealing 19th-century residence. It specializes in photography, inviting visitors to trace the history of the art, from the daguerrotype to ultra-modern techniques. It also offers a rich program of frequently changing exhibitions.

Not far from the Elysée, the **Olympic Museum** (quai d'Ouchy 1) has a detailed display on the history of sports.

The Vaud Riviera

This region extends from the suburbs of Lausanne to the eastern edge of the Lake of Geneva. Villette, Epesses, and Saint-Saphorin are typical wine-growing villages, depicted in literature by C. F. Ramuz, a writer from the Vaud region. Whatever your method of transportation (boat, train, or car), the landscapes of the Lavaux are something to see.

Just before Vevey, at Corseaux, a white wall draws your eye: it is the **Villa Le Corbusier**, designed in the early 1920s by Le Corbusier and Pierre Jeanneret.

Chocolate and wine are the twin foundations of **Vevey**'s fortune. In fact, the largest building in town, a glass structure with concave walls, is the worldwide center for Nestlé, the famous multinational food manufacturer. And viticulture, the region's other important resource, has given rise to the Fête des Vignerons (Vineyard Festival), celebrated every 25 years or so since the 16th century (the latest one in 1999). This popular festival brings together thousands of willing participants from the region, creating a splendid spectacle.

The old town is a wonderful place to explore. Among the 18thand 19th-century houses are squares with many fine old fountains.

A cog train goes from Vevey to **Les Pleiades**, a belvedere with a panoramic vista at 1,360 m (4,462 ft) above sea level. Here you can take in the entire lake with the Alps behind it. Halfway up, **Blonay** is both the site of a 12th-century castle and the end of the line for a small tourist railway (the Blonay-Chamby line) whose steam engine and cars date from the turn of the century.

Far above the vineyards and orchards of Vevey, a funicular climbs to the next vista, **Mont-Pèlerin**. Don't miss the panoramic tower, the "Plein Ciel" (Open Sky), with a 360-degree view of the whole lake region.

Near the far end of the lake, the fin-de-siècle palaces of **Montreux** attract tourists all year round. Vladimir Nabokov, author of *Lolita*, spent his final days in one of these hotels.

Montreux owes its Mediterranean atmosphere to a meterological microclimate which favors all kinds of blossoming plants.

Montreux is also the setting for international shows such as the prestigious Montreaux Jazz Festival (July), the "Musical September" classic music festival, the Golden Rose Festival, and the

Festival of Laughter (April and May). The casino, Switzerland's first, looks out on the lakefront, adding to this resort's appeal.

The **old town**, tucked into the hillside, also charms, with its 18thcentury stone houses, antiques shops, and artisan's boutiques.

A mountain train climbs to **Rochers-de-Naye**, at an elevation of more than 2,000 m (6,562 ft), passing through orchards, pastures, and forests: the view is stupendous. The site is also a haven for hikers, rock-climbers, and skydivers.

If you like your landscapes as seen through a window, board the one-of-a-kind Panoramic Express. A brainchild of the Montreux-Oberland Bernois (MOB), this train offers an unbeatable view over the Lake of Geneva before continuing on to Gruyère (where the famous cheese is made), Château-d'Oex, Rougemont, Gstaad, Zweisimmen, Interlaken, and Lucerne.

East of Montreux, the most famous of all Swiss châteaux, the **Château de Chillon**, is an austere feudal fortress, oddly wedged between the lake and the railroad. The great rock of Chillon, projecting out over the Lake of Geneva, was always a natural stronghold from which to guard the major Saint Bernard road linking Rome to its northern provinces. There were probably fortifications on the spot since ancient times, and an early, rudimentary château, which belonged to the bishops of Sion, was later fortified and enlarged by the dukes of Savoy. In 1536, after a three-day siege, the fortress fell into the hands of the Bernese.

Four Resorts in Vaud

The resorts of Vaud have developed modern infrastructures without losing their Old-World character. It is this balance between innovative energy and tradition that explains their popularity and appeal.

Château-d'Oex (960 m/3,150 ft), a pleasant village snuggled into the welcoming valley of the Pays d'Enhaut, is ideal for family vacations. The interesting Musée du Pays d'Enhaut showcases the arts, crafts, and history of the region. You can also visit Etivaz to watch the local craftsmen make the cheese of the same name. At the end of January, one of the most famous international airshows takes place here, bringing together over a hundred hot-air balloons.

Les Diablerets (1,150 m/3,770 ft). This family-style resort occupies a beautiful Alpine site. A cable car makes three stops on the way to the top of one of Switzerland's most impressive glaciers—Les Diablerets (3,000 m/9,840 ft), where skiing goes on all year.

Leysin (1,250 m/4,100 ft). This spectacular sunny spot, facing the Dents du Midi and the Mont Blanc mountain range, has beginning and intermediate-level slopes. Each January, Leysin plays host to the European Snowboard Championship.

The setting sun highlights the towers of Lausanne's Gothic cathedral with a rosy glow.

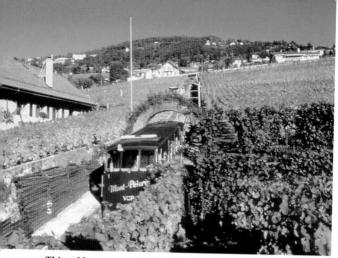

This cable car ascends through orchards and vineyards, carrying passengers to Mont-Pèlerin.

Villars-sur-Ollon (1,250 m/4,100 ft). A family resort full of activity all winter, and summer weekends, with sports ranging from downhill and cross-country skiing, and skating, to horseback riding, swimming, tennis, and golf. Gryon (1,110 m/3,640 ft) is a continuation of and complement to Villars. Gryon has preserved its traditional character, and its abundant fauna and flora make it an unmissable gem.

FRIBOURG, NEUCHATEL, AND THE JURA

These three adjacent cantons have very distinct characters and strong personalities of their own.

Fribourg

The hilly terrain of Fribourg has made it a city in three dimensions, built at once along the Sarine river (*Saane*, in German) and on a cliff

above it. What first strikes the visitor's eye is the harmony between the wild gorges and the marvelous Gothic buildings.

Founded in 1157 by Duke Berchtold IV of Zähringen, Fribourg joined the Confederation in 1481. When the Reformation seized Bern, Fribourg resisted. Today, it remains steadfastly Catholic, with its churches, seminaries, and bookstores specializing in theology. Even its university is Catholic.

Fribourg is also a bilingual city. Since the 15th century, when Latin was abandoned by the clerics, French and German have alternated as the predominant language. French finally took over in 1830, but it is now losing ground once again.

Sightseeing begins with the dramatic setting of Fribourg: Zähringen Bridge offers the classic scene of the river, the 13th- and 15th-century ramparts on the steep hillside, and the old covered bridge linking the banks of the Sarine. There has been a bridge at this point since the 13th century, replaced after every major flood.

Like all the historical buildings of Fribourg, the **Cathédrale Saint-Nicolas** is made of sandstone. Age, weather, and pollution have left their mark. The Gothic statues that frame the main portal are copies; the originals have been safely placed in the Catholic University and the Museum of Art and History. Inside the cathedral, note the striking sculptural ensemble *Entombment of Christ* (1433) in the Chapel of the Holy Sepulchre.

Another important architectural work is the **Eglise de Cordeliers**, founded in the 13th century by Franciscan monks. Among its highlights are the oak choir stalls (1280), a very fine altarpiece (1480) above the main altar, and, in one of the side chapels, a magnificent triptych of sculpted and gilded wood (1513).

The **Musée d'Art et d'Histoire** (Art and History Museum) is installed in the Hôtel Ratzé, a splendid Renaissance residence; part of it also occupies a nearby 19th-century slaughterhouse. The very eclectic collections of this museum are essentially based on the past of Fribourg and its immediate environs.

Riders are conveyed in turn-of-the-century railway carriages on the Blonay-Chamby line.

Just next to the Art and History Museum, the space devoted to the works of Fribourg native Jean Tinguely and his companion, Nicki de Saint-Phalle, is a definite must. One of Tinguely's most famous constructions, La Fontaine, is in the Grandes Places public garden.

The **Hôtel de Ville** (Town Hall), notable for its great sloping roof, its covered ceremonial staircase, and its turreted clocktower, dates from the early 16th century.

Around Fribourg

Murten (Morat). This bilingual town is a marvel of perfectly preserved old houses with deep arcades and overhanging roofs. You can

climb up to the medieval towers and ramparts to survey the tile roofs, the town's little lake, and the countryside.

Also worthy of note here is the 13th-century castle and the solid Bern Gate, with its bell and belfry.

In summer, some excursion boats go from the Murten lake to Biel and Neuchâtel.

Avenches. Aventicum was the capital of Roman Helvetia. Around A.D. 260, it was sacked by Alemanni tribesmen, and no one knows what happened to its 20,000 inhabitants. During the Middle Ages, a new city was founded on the same site, but its

prosperity never approached that of the ancient capital.

At the far end of the rue Centrale, visit the **amphitheater**, where over 8,000 spectators could gather to watch gladiators in the Roman era. Today, it is used for open-air operas. Above the main entryway, a medieval tower now houses the **Roman Museum**, whose wellpresented collections are supplied by archeological digs that are ongoing at the site.

Payerne. This small town in the Broye valley is home the **Abbatiale**, the largest Romanesque church in the country and the only remaining vestige of an important Benedictine abbey. After the Reformation, this remarkable building was abandoned. But more than a half-century of restorations have revealed architectural elements from the 11th century, such as the majestic columns supporting the vaulted ceiling. In an upstairs chapel,

there is a collection of Romanesque sculptures depicting animals and saints with anxious faces.

Romont. Walk the 13th-century ramparts that surround this merchant town perched on a hill between Fribourg and Lausanne. In good weather, the view of Fribourg's lower Alps is superb. The collegiate church, a formidable Gothic structure, is lit by fine medieval and modern windows. A pretty château has become a museum devoted to the art of stained glass from the Middle Ages to the present.

Gruyères. This large, fortified medieval village, high on a hilltop, draws tourists from the world over. All along the cobblestoned main street, pipe-smoking peasants contemplate life from their benches.

The castle, built by the counts of Gruyères in the 12th century, is definitely worth a visit, if only for the view from the battlements. The worn steps of the spiral staircase lead you to the well-preserved state rooms and private apartments.

Don't leave Gruyères without tasting some of its specialties: fondue, meringue, and raspberries and blueberries, all served with the thick, smooth cream particular to this region. At the foot of the hill, a model dairy shows you the secrets involved in making the famous Gruyère cheese.

Bulle, 11 km (7 miles) from Gruyère, is the location of a fine 13th-century castle (not open to visitors) and the **Gruyères Museum**, which illustrates the customs of the region.

Neuchâtel

The "tick-tock" of official Swiss time is emitted by the Chronometric Observatory of Neuchâtel, which is the definitive research center for the clockmaking industry. This lakeside city's long intellectual tradition lives on in its university, its schools, and its specialized institutes.

The city has belonged, successively, to the Holy Roman Empire, the dukes of Burgundy, and the kings of Prussia. It was not until 1857 that Prussia officially recognized the independence of the canton, even though it had been a member of the Confederation since 1815.

The old crossroads of the Croix du Marché, located a few streets in from the port, is adorned with buildings and fountains built between the 16th and 18th centuries. The most original structure here, the **maison des Halles** (1575), was once a covered market.

The town is dominated by a monumental grouping of medieval buildings, where once church, prison, and government shared a fortified enclosure. Inside the **Collégiale** (collegiate church), a remarkable sculpture immortalizes the counts of Neuchâtel. The castle (12th–16th centuries) is now the seat of the cantonal government. The top of the prison tower (15th century) commands the best view of the city and the lake.

To the west, on rue Saint-Nicolas, the **Musée d'Enthnographie** (Ethnographic Museum) has several good collections relating to Ancient Egypt, Africa, and Oceania.

The two most important museums in town share the same building on the rue des Beaux-Arts, close to the port. The **Musée des Beaux-Arts** (Fine Arts Museum) is dedicated to Swiss artists and to religious painting of the Middle Ages. The **Musée de l'Histoire** (History Museum) brings together rare Swiss ceramics, 16th-century watches, armor, coins, and medallions.

Not far from Neuchâtel, in Marin, a curious site attracts many visitors. Beneath two cupolas about 40 m (130 ft) each in diameter, two tropical biospheres have been constructed, one representing daytime, (**Papiliorama**), the other night (**Nocturama**). The first brings together fish, tortoises, and water birds in an aquatic setting. The second houses nocturnal species of animals from the forests of Central and South America, among them the very likable and eminently watchable sloths. The idea behind this enterprise is to attract the attention of visitors to the critical importance of protecting the world's forests.

A few kilometers from Neuchâtel, the **Travers Asphalt Mines** invite you to enter a subterranean world (the corridors of the mine comprise over 100 km/62½ miles); this was the universe of those who extracted asphalt for three centuries (from 1712 to 1986) for export all over the world. Guided tours are available; in the café you can try a local specialty: ham cooked on asphalt heated to 160°C (320°F).

Neuchâtel and the Three Lakes region (Biel, Murten, and Neuchâtel) are currently organizing an elaborate national exposition on the theme "Time, or Switzerland in Movement," which will open its doors in 2001.

Around Neuchâtel Lake

Grandson. This charming town was the scene of a famous triumph in Swiss history: the 1476 defeat of Charles the Bold, Duke of Burgundy, by valiant Confederate troops. At the castle, you can see a reenactment of this event with lead soldiers. Take advantage of your trip to the castle to climb the ramparts (13th century) and to visit the underground museum of antique cars, featuring Greta Garbo's 1923 Rolls Royce.

Yverdon-les-Bains. Known for its mineral baths since Roman times, this spa is flourishing again. In the center of town, a 13th-century castle houses the municipal museum. One room is devoted to Pestalozzi, a pioneer of pedagogy, who ran a school here in the 19th century.

Estavayer-le-Lac occupies the south bank of Neuchâtel lake. Many varied architectural styles coexist in this walled city. The Château de Chenaux dates from the 13th century, while the Saint-Laurent church in the heart of town is mainly of late Gothic style.

A most surprising attraction is the Museum of Frogs, which is installed in a typical setting of everyday life in the 19th century.

A study in contrasts: Fribourg's dark-green river flows around the red-tiled medieval city.

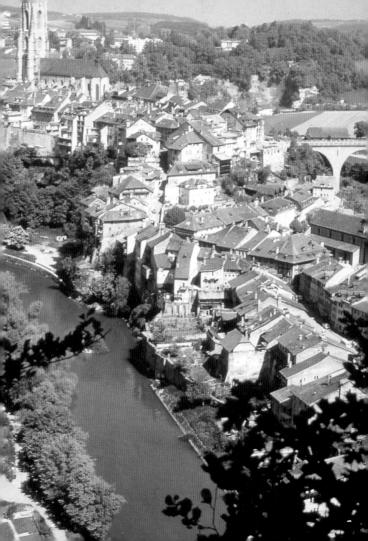

The Jura

French-speaking Jura is the baby among Swiss cantons (1979). The Jurassic range links Geneva to Basel, accompanying the French border on one side and stretching across a half-dozen Swiss cantons on the other. It is a zone of meadows, lakes, and fir forests interspersed with the region's typical dwellings, enclosed in drystone walls.

Life is harsh in this sparsely populated region, where for centuries watchmaking, practiced at home, was the economic mainstay. Switzerland appears less opulent and prosperous here. But for the tourist seeking peace and beauty, the Jura is a great discovery.

Romainmôtier. This magnificent village, tucked into a tiny idyllic valley, takes its name from the monastery (*moîtier* in old French) founded here around A.D. 450 by Saint Romain. The church, dating

The main street of Gruyères, one of the most charming in Switzerland, is a favorite with visitors.

from the tenth and 11th centuries, is absolutely remarkable. You can still see, on the floor in front of the organ, the traces of two earlier churches. The frescoes are from the 12th and 13th centuries; the Romanesque sculptures represent demons and wonders of the medieval world. In the choir, there is a sculpted seventh-century ambon (a kind of pulpit in early churches).

The 14th-century clock tower and the 15th-century priory are all that remains of the monastery.

La Chaux-de-Fonds. In this city of 40,000 inhabitants devoted to clockmaking, the main attraction is the "Man and Time" exhibition at the Musée International d'Horlogerie (International Clockmaking Museum). It is unique, both architecturally—the museum is entirely underground—and in its collection. With over 3,000 timepieces on display, from sundials to hourglasses to the most modern chronometers, it is the most important museum of its kind in the world. Note especially the 17th-century enameled watches.

Native son Le Corbusier realized some of his earliest projects here. The fruits of this era include: the Fallet villa (1906, decorated in Jurassian Art Nouveau), the Jacquemet villa (1908) and the Stotzer villa. The character of the architect can be seen in the mature design of the Villa Turque (1917). Some time after these projects were completed, Le Corbusier moved to Paris.

To the north of the city begin the forests and pastures of the **Franches-Montagnes**. This peaceful region's main activity is the raising of horses.

Saignelégier, the county seat, welcomes important events each year, such as the traditional Horse Fair and Market (in summer) and the dogsled races (in winter).

Saint-Ursanne. The impetuous Doubs river, originating in France, encloses this delightful little town, where pink, white, and ochre-colored stone houses vie for space on the riverbank. After crossing the narrow, swaybacked bridge, you enter the walled city, where life revolves around the **Collégiale** (collegiate church). Like

the village, the church takes its name from Saint Ursinicus, an Irish pilgrim of the 12th century, who lived as a hermit in the Doubs valley.

Porrentruy. In 1527, the bishop-prince of Basel came here to flee the Reformation. In the two and a half centuries that followed, Porrentruy has played an eminent role in political and religious life.

The Town Hall and some public buildings from the 18th century attest to the close ties between this region and nearby France. Indeed, during the Revolution, France annexed this city for a time. The attractive residences built during that period give Porrentruy more of a French than a Swiss air.

GENEVA

Cosmopolitan city par excellence, Geneva manages to be tranquil and overflowing with the good life at the same time. No wonder diplomats and functionaries from all over the world dig their heels in and hold on to this city full of art and history when faced with the prospect of a job transfer. Geneva, magnificently situated, offers luxury boutiques, fine restaurants, and lakeside parks, all within a stone's throw of the nearby mountains.

Geneva's geographical location has been considered a strategic one since A.D. 58, when Julius Caesar and his troops destroyed the ancient bridge over the Rhone to halt the movement of Helvetian troops toward Gaul. Since then, many a sovereign has coveted Geneva, at once a communications nexus and a center of trade. Thus, the city has been under the control of, respectively, the dukes of Burgundy, the German emperor, the dukes of Savoy, and, briefly, Napoleon Bonaparte.

In 1602, several thousand mercenaries brought in by the duke of Savoy besieged the city. Taking advantage of a particularly dark night, they scaled the city walls, but the spears wielded by Geneva's men, along with (according to legend) the boiling soup hurled by its women, got the better of them. Each year around 11 December, the *Escalade* (Scaling of the Walls) is commemorated by a torchlight procession and a series of masked balls.

The French theologian Jean Calvin made Geneva a great center of Protestantism. In 1541, its citizens exhorted him to become their spiritual guide. Calvin imposed an iron discipline and an austere life on the city; Protestant refugees and pilgrims continued to flow into the "Protestant Rome." Today, tolerance reigns. The city is now the seat of the Ecumenical Council of Churches, and contains several Protestant, Catholic, and Orthodox sanctuaries, a synagogue, and a mosque.

A Stroll Through Geneva

The tallest monument in Geneva and a symbol of the city, the **water jet** is visible from many parts of town: its jet of water reaches the height of a 40-story building.

The imposing Mont-Blanc bridge links the two parts of town. Here you will see the sudden narrowing at the spot where the peaceful lake becomes a powerful river. The Rhone, which originates in the Alps, crosses Lake Geneva in its entirety before resuming its course toward the Mediterranean. From the bridge on the right bank, Mont Blanc can often be seen peeking out from the stretch of the French Alps.

Note, to the west of the bridge, Rousseau Island (actually an artificial island created in the 16th century), accessible on foot by the Bergues bridge. The statue facing the lake represents the famous writer and philosopher Jean-Jacques Rousseau (1712–1778). Downstream, the river is split in two by what the Genevans call simply the **Island**. Only a watchtower remains of the castle built here in 1219.

Once you have crossed the river, you enter the luxurious **shopping district**. Wander down the rue du Rhône, the rue de la Confédération, the rue du Marché, the rue de la Croix-d'Or, and the rue de la Corraterie—an elegant boulevard that ends at the

place Neuve. Here stand three impressive buildings: the **Grand Théâtre** (inspired by the Garnier Opéra in Paris), the **Conservatoire de Musique**, and the Musée Rath (see page 136), a sublime Greek-style structure built in 1826 as the first fine-arts museum in all Switzerland.

Pass through the metal gates into the park on the place Neuve, Promenade des Bastions, to see the striking **Reformation Monument**. Built in 1909, the 400th anniversary of the birth of Calvin and the 350th of the foundation of the Geneva Academy, this 100-m- (330-ft-) long wall bears religious inscriptions in several languages. The group of sculptures at the center represents Calvin and three of his companions, the French reformers Théodore de Bèze and Guillaume Farel as well as the Scottish preacher John Knox. Facing the monument is the main building of the University of Geneva, which is the offspring of Calvin's Theological Academy.

After the gardens, continue your walk into the **old city**, well preserved with its maze of streets and historic dwellings. Because of its strategic location, this was the first place chosen by the Romans to build fortifications.

If you take the rue Saint-Léger at the end of the Promenade des Bastions, you will arrive at the **Place du Bourg-de-Four**, with its charming fountain, surrounded by the Palais de Justice (1712) and some lovely houses (16th–18th centuries). Take the rue de l'Hôtel-de-Ville, lined by the most prestigious antiques stores in Geneva, and continue to the place de la Taconnerie. A few steps away is the cathedral.

The highest spot in the old city has been a place of worship of some kind since pagan antiquity. In the 12th century, construction began on **Cathedrale Saint Pierre** (St. Peter's cathedral), first in the Romanesque and later in the Gothic style. In the 18th century the façade was adorned with classical columns that still provoke controversy today.

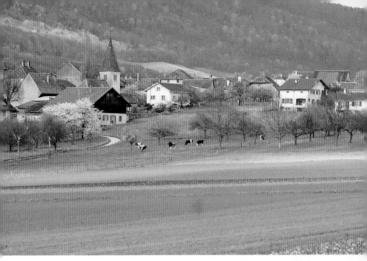

Farm animals prosper on a diet of the rich grass that grows off the beaten track, in the Jura.

The interior is as austere as the doctrine Calvin preached here for more than 20 years. From the top of the northern tower (take the elevator), between the bells, you have an exceptional **view** of Geneva and surrounding areas.

The **Tavel House** (the Museum of Old Geneva), on the rue du Puits-Saint-Pierre, is the oldest dwelling in Geneva. On the corner of the rue de l'Hôtel-de-Ville, be sure to notice the **Arsenal**, once a wheat granary. Under its arches, cannons from the 17th and 18th centuries are symbolically deployed as if for battle. The three wall mosaics, dating from 1949, represent important episodes in the city's history.

On the other side of the street, the **Hôtel de Ville** (Town Hall), seat of the cantonal government, boasts an elegant Renaissance courtyard where concerts can be heard in summer. In this building,

the Geneva Convention, the first convention agreement on the treatment of prisoners of war, was signed in 1864.

Just past the Hôtel de Ville, follow the picturesque **Grand-Rue**, lined with buildings from the 15th to the 18th centuries; one of them, number 34, was once the workshop of Ferdinand Hodler. A little farther down, number 40 is the birthplace of Rousseau. Parallel to this street, the **Rue des Granges**, a bastion of the great bourgeois families of Geneva, distinguishes itself by its beautiful Louis XVIstyle houses.

The **Eglise Russe** (Russian Church), next to the Museum of Art and History, deserves its own detour. Dating from 1866, its splendid gilded cupolas are worth a look.

Another curiosity of the old town is the **Cimetière de Plainpalais** (Plainpalais cemetery), where various Genevan personalities, including Jean Calvin and Augustin de Candolle (the creator of the Conservatory and the Botanical Garden) rest in peace.

Next to the Pont de la Coulouvrenière, you will notice the splendid **Bâtiment de Forces Motrices** (Moving Forces Building), formerly a hydroelectric plant, built in 1866. Today it contains a large hall dedicated to lyric art.

Another mythical spot in Geneva is the **Bains des Paquis** (Paquis baths), dating from 1932 and recently renovated. This natural swimming pool is built on the port.

In the old neighborhood of Grottes, behind the train station, a mirage appears before your eyes: the Smurf houses (1982–1984), a series of buildings with unconventional shapes, full of humor, color, and decorated with bright mosaics.

Those who enjoy unconventional architecture in general can also visit the building called "Clarity" (*La Clarté*), designed by Le Corbusier, located in the Villereuse neighborhood. Considered avant-garde at the time of its construction in 1931–1932, this steel-covered building allows the maximum amount of light to enter. A trip to the Bonnier Gallery, housed inside, which specializes in the

works of Tinguely and Nicki de Saint-Phalle, will give you a chance to appreciate the ingenious design.

Geneva, International City

The elegant Wilson Quay, on the right bank of the lake, honors the memory of the American president who influenced Geneva's destiny so profoundly after the first World War. At the end of the quay, the Wilson Palace, which dates from 1875 and was destroyed by a fire in 1987, has regained its splendor after years of renovation. The city, which had so long been a center for banking and watchmaking, took on an international dimension when Woodrow Wilson made it the world capital of diplomacy by choosing it, in 1920, to be the world-wide seat for the Society of Nations.

Since then, innumerable organizations and international agencies, including the International Labor Office (ILO), the General Accord on Customs Tariffs and Commerce (GATT), the International Red Cross Committee, and the World Health Organization (WHO) have chosen Geneva as their home.

La Chaux-de-Fonds, in the Jura, has been practicing the craft of watchmaking for centuries.

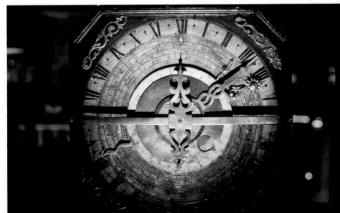

A detail from Geneva's Reformation Monument in the Promenade des Bastions.

The vast Palais des Nations. conceived as the headquarters of the Society of Nations, was inaugurated in 1937, with the specter of war already looming over attempts at international cooperation. After World War II, the newly gathered United Nations Organization claimed the building, at the heart of Ariana Park, as its European headquarters. Now that the activities of the UN, as well as the size of its staff, have inexorably grown, the building has been enlarged. Guided tours take you to the historic rooms inside, notably the Council Hall with its remarkable frescoes. the quite impressively sized Assembly Hall, and the Rockefeller Library with its many volumes and international documents. The Visitors' Center

(rue de Montbrillant) of the **High Commission for Refugees** is set up in what used to be a gas station (1927); the structure, designed by Maurice Braillard, is classified as a historical monument.

Parks and Gardens

Geneva is rightly proud of its huge parks, with their fountains, sculptures, pavilions, and cafés.

The **English Garden**, on the left bank, is known mainly for its giant floral clock (5 m/16 ft in diameter), whose immense face is

made up of thousands of flowers and plants, replanted twice each year. The clock symbolizes Geneva's watchmaking industry.

The rose garden in the **parc de la Grange**, with a rich collection of over 200 varieties, is especially radiant in June.

On the right bank, Geneva's most pompous monument, the mausoleum of the duke of Brunswick (1804–1873), presides over the **Jardin Brunswick** (Brunswick Garden) on Quai des Mont-Blanc. The duke, who spent his last years in exile in Geneva, left his immense fortune to the city on the condition that a mausoleum be erected in his honor.

After crossing the **Mon-Repos** and **Perle du Lac** parks, you will arrive at the **Botanical Garden**. This ensemble brings together greenhouses filled with tropical plants, a pond filled with aquatic vegetation, an arboretum, a rock garden covered in mountain plants, and an aviary.

Geneva's Museums

Geneva is a very active city culturally and artistically, and is particularly rich in museums, foundations, and galleries. At the **Musée d' Histoire Naturalle** (Museum of Natural History), you can traverse 2 km (about 1 mile) of corridors on several levels, viewing some 3,000 species of mammal and marine life. The birds are accompanied by samples of birdsong and the surrounding noises of their environment.

Musée d'Art et d'Histoire (Museum of Art and History). The most important of Geneva's museums, this institution not only possesses a remarkable archeological collection, but also sections devoted to the fine and decorative arts. The painting department boasts works by Dutch, Flemish, French, and Swiss masters. The most precious work here is the altarpiece from St. Peter's cathedral, painted by Konrad Witz in 1444. Entitled *La Pêche Miraculeuse* (The Miracle of the Fishes), this painting is the first in art history to represent an identifiable landscape. In it, Christ is seen walking on the

waters of the port of Geneva, with Mount Salève visible in the background. Important temporary exhibitions organized under the auspices of the Museum of Art and History are presented at the **Musée Rath**. This museum welcomes modern and contemporary art, retrospectives of individual artists, and archeological exhibitions.

The **Centre d'Art Contemporain** (Center for Contemporary Art) offers temporary exhibitions of new experimental artists, performances, conferences, and also film and video screenings. The former factory for the Geneva Society for Physics Instruments is now the headquarters for the **Musée d'Art Moderne et Contemporain** (**MAMCO**), with 4,000 sq m (13,120 sq ft) of surface area devoted to widely varying exhibitions.

Saint-Gervais is home to the Centre pour l'Image Contemporaire (Center for the Contemporary Image), which shows photography exhibitions and video art (it has one of the most remarkable video collections in Europe, notably including the complete works of Bill Viola and Gary Hill). Also very interesting is the Photography Center in the Maison des Arts of Rütli.

In the old city, the **Petit Palais** brings together a large selection of paintings, sculptures, and drawings covering a half-century (1880–1930), from Neo-Impressionists and Pointillists to Cubists and Fauvists.

The **Musée de l'Ariana** shelters one of Europe's most splendid collections of ceramics (pottery, sandstone, faïence, and porcelain) and glass (blown, molded, engraved, and cut).

The **CERN** (European Center for Nuclear Research), the world center for research in particle physics, is located in Meyrin. Here, you are invited to the "Microcosm" exhibit, where your knowledge of all of the elements of the universe is sure to grow.

For those visitors whose interests tend toward the less abstract, the **Musée Jean Tua de l'Automobile, de la Moto, et du Cycle** (located in the same building as MAMCO and the Center for Contemporary Art) houses and displays some of the earliest mod-

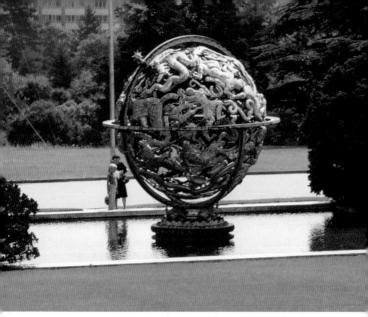

Artworks grace much of Geneva's open space: here, a fitting sculpture at the Palais des Nations.

els (1877–1939) of makes such as Hispano, Citroën, and Mercedes. Also worth visiting is **Musée International de l'Automobile**—the largest in Switzerland—in Palexpo (near the airport, with over 14,000 sq m/45,930 sq ft of exhibition space): a stunning panoply of makes and models that have left their imprint on the history of the automobile.

Carouge

Though it may seem to be nothing more than a suburb of Geneva, Carouge is actually an independent municipality, with its own par-

Major Sights — Geneva

Museums and Art Centers

Centre d'Art Contemporain: rue des Vieux-Grenadiers 10; Tel. (011) 329-1842; Tuesday–Sunday 11am–6pm; 4–9FS (children under 13 enter free)

Centre de la Photograhhie: Grütli Art House, rue du Général Dufour 16; Tel. (022) 329-2835; Tuesday-Wednesday 2:30–6:30pm, Thursday 2:30–9pm, Friday-Saturday 2:30–6:30pm (closed July-August); free

MAMCO, Musée d'Art Moderne et Contemporain: rue des Vieux-Grenadiers 10; Tel. (022) 320-6122; Tuesday 12–9pm, Wednesday–Sunday 12–6pm; 2–4FS (children under 16 enter free).

Microscosm, Expositions des Sciences et Technologies: CERN, European Laboratory for Particle Physics, Route de Meyrin, 1217 Meyrin; Tel. (022) 767-8484; Monday 2–5pm, Tuesday–Saturday 9am–5pm; free.

Musée d'Art et d'Histoire: rue Charles-Galland 2; Tel. (022) 418-2600; Tuesday–Sunday 10am–5pm; free for permanent collection, 5FS for temporary exhibitions

Musée d'Historie Naturalle: Route de Malagnou 1; Tel. (022) 418-6300; Tuesday–Sunday 9:30am–5pm; free for permanent collection, price varies for temporary exhibitions

Musée de l'Ariana – Musée Suisse de la Céramique et du Verre: avenue de la Paix 10; Tel. (022) 418-5450; Wednesday–Monday 10am–7pm; free for permanent collection, 5FS for temporary exhibitions

Musée International de l'Automobile (Palexpo): Voiedes-Traz 40, 1218 Grand Saconnex; Tel. (022) 788-8484/82; Tuesday–Sunday 10am–7pm; 6–12FS (children under 6 enter free). Musée Jean Tua de l'Automobile, de la Moto, et du Cycle: rue des Bains 28-30; Tel. (022) 321-3637; Wednesday–Sunday 2–6pm; 4–8FS.

Musée Rath: Place Neuve 1; Tel. (022) 310-5270; Thursday-Tuesday 10am-5pm, Wednesday 12-9pm; 3-10FS (children under 16 enter free).

Petit Palais: Terrasse St.-Victor 2; Tel. (022) 346-1433; Monday–Friday 10am–12pm and 2–6pm, Saturday–Sunday 10am–1pm and 2–5pm; 5–10FS (children under 13 enter free)

Saint-Gervais – Centre pour l'Image Contemporaine: rue du Temple 5; Tel. (022) 908-2000; Tuesday–Friday 10am–8:30pm Saturday–Sunday 2–6 pm; free

Places of Interest

Bains des Pâquis: Paquis Jetty, quai du Mont-Blanc 30; Tel. (022) 732-2974; May and September 10am–6pm, June–August 9am–8pm, sauna rooms open in winter

Jardin Botanique de la Ville de Genève: Chemin de l'Impératrice 1, 1292 Chambésy-Genève; Tel. (022) 418-5100; Garden open October–March 9:30am–5pm and April–September 8am–7:30pm, Serres open Saturday–Thursday 9:30–11am and 2–4:30pm, guided tour Tuesday noon (May–October) by appointment; free

Jet d'eau: Quai Gustave-Ador

Le Corbusier - "La Clarté": rue de Saint-Laurent 2-4

Palais des Nations: Door 39, Avenue de la Paix (tour entry at the Pregny portal); Tel. for tour reservations: (022) 907-4896, 907-4539; April–October Monday–Sunday 10am-12pm and 2–4pm; July–August Monday–Sunday 9am–6pm; November–March Monday–Friday 10–12am and 2–6pm; 5–8.50FS

A Genevan gallery window reflects an example of its architecture from across the street. ticular history. It was founded at the end of the 18th century by the king of Sardinia, who happened also to be the duke of Savoy. The project was an attempt to rival Geneva. Although these plans have more or less remained unrealized, there is no denying the meridional inspiration of the fountains, squares, forged-iron streetlamps, and houses of the "Sardinian city."

The Genevese love Carouge for its bohemian atmosphere, theatrical and artistic productions, and lively bars and restaurants.

Foreign Affairs

Geneva is bordered on three sides by France, and crossing the border here is as normal as crossing town. Here are two spots that the Genevans particularly love:

Mount Salève. This mountain has been such a part of the familiar landscape of the Genevans that it has become a symbol of the city, just like the water jet or the Palais des Nations. Every weekend, its cliffs crawl with rock-climbers.

Divonne. In this French village, 18 km (11 miles) north of Geneva, you can restore your health or (though much less likely) your fortune. The area's two main attractions are its **thermal baths** and its **casino**. In summer, Divonne's numbers swell, thanks to golf courses, horseback riding, sailing, and a remarkable chamber-music festival.

WHAT TO DO

SPORTS

Downhill skiing. Whether you're a champion or a beginner, Switzerland remains the homeland of this sport, offering the best possible conditions of comfort and safety, not to mention the most beautiful landscapes.

Nearly 200 villages and small towns are equipped for downhill skiing: the Valais offers a wide choice of resorts, including Zermatt, Crans-Montana, Saas-Fee, or Champéry, from which you can reach the Portes du Soleil (650 km/400 miles of slopes, with 230 mechanical lifts). The Grison range is also active, with St. Moritz, Pontresina, Davos, and Klosters, as well as Flims and Laax, with their Alpenarena. The Alps of Vaud, the Jura, and central

Switzerland also offer wonderful ski slopes. In most regions the season lasts from late November through early April, but conditions vary according to the year and the resort. The high seasons (that is, when prices and crowds are at their height) are Christmas, Easter, and the month of February. Outside of these times, you can get better package deals, which include hotel, meals, and lift tickets. Throughout winter, the Swiss

A ski trip in Switzerland calls for some functional and fashionable gear.

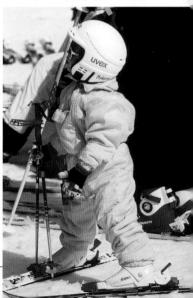

ski schools organize excellent group courses taught by qualified professors, who will also give private lessons.

Before hitting the slopes, don't forget to bring sunblock and sunglasses to protect you from the blinding glare of the snow. Be cautious: regulate your speed according to your physical condition and level of expertise in order to avoid having to call the security patrols (efficient and well-equipped though they are).

Snowboarding. The growing number of snowboarding fans will not be disappointed with what Switzerland has to offer. Besides the innumerable classic slopes that can be shared with skiers, many resorts are beginning to set aside special areas with jumps, obstacle courses, and a young, "cool" atmosphere (Grindelwald First and Adelboden Hahnenmoos, to name two).

Snowblading. This recent addition to the world of winter sports, practiced on 90-cm- (35-inch-) long boards without ski poles, is wonderfully exhilarating. If you don't dare go it alone at first, remember that many ski schools offer snowblading courses.

Cross-country skiing (*Langlauf*, in German). This sport has come back into fashion in recent years. Glide through the wooded countryside or follow a stream or river, stopping along the way for a picnic or lunch on a restaurant's terrace. The tracks are groomed and ranked according to difficulty. Some resorts have up to 100 km (62 miles) of tracks, and new ones are being opened each year. The Jura, the Engadine, and Appenzell are particularly popular locations.

Equipment for all winter sports can be rented on site.

Skydiving and hang-gliding. Switzerland's dramatic terrain is particularly well-suited to these sports so beloved by thrill-seekers (at Lenzerheide, Rigi, Salève, and St. Moritz).

Skating. Most resorts have natural or artificial skating rinks open throughout the winter. Skate rental and lessons are available.

The fine powder and sheer mountainsides of the Alps are what draw so many skiers year after year.

Curling. This sport, which involves sliding heavy polished blocks of stone across the ice, can be practiced in many places in Switzerland. Both open-air and covered tracks are available.

Summer skiing. In resorts near glaciers, such as Les Diablerets, Verbier, Zermatt, Saas-Fee, and Pontresina, you can easily ski all morning and swim all afternoon. Many of them operate lifts and cable cars all summer, to the delight of skiers, climbers, and hikers.

Rock-climbing. For this sport, a professional guide and adequate equipment are of crucial importance. Rescuers often bewail the carelessness of people who dress as if for a tennis match to navigate difficult, often unpredictable rockfaces. The best option for new-comers is to take a climbing course.

Mountain trekking. Trekking is less dangerous, but it is still important to take precautions and to be well equipped, with good shoes and an anorak. Be careful not to leave the marked paths. For greater safety, get detailed maps from the local tourist office. The Swiss Alpine Club also has a list of huts available in the mountains.

Hiking. Switzerland boasts about 50,000 km (31,250 miles) of marked hiking trails. Wherever you go, you will see yellow signs that designate the trails and indicate the destination time to the next checkpoint. It is easy to find books, leaflets, or maps suggesting the most attractive hiking destinations in the region. Many communities organize group hikes or climbing trips.

Swimming. Switzerland's lakefronts, beaches, and creeks are available to everyone. Most cities and resorts have beaches as well as swimming pools, not to mention the thermal baths at resorts such as Bad Ragaz, Loëche-les-Bains, Yverdon, Ovronnaz, and Scuol.

Sailing. Hardly a weekend goes by in summer without a major regatta taking place somewhere in Switzerland. You can rent boats or paddleboats on most lakes. You will need a permit to navigate a sailboat with a sail larger than 14 sq m (46 sq ft), but you can content yourself with a small craft or a canoe. Beware the sudden gusts of wind, which often arise on Swiss lakes.

For some fair-weather sporting, try sailing on one of Switzerland's many crystal-clear lakes.

Waterskiing. This expensive sport is practiced at most major resorts; on some lakes it is forbidden for environmental reasons.

Windsurfing. You can rent equipment to experience this evermore-popular sport; coaches will help you get yourself afloat.

Fishing. Lakes and rivers are restocked each year (with trout, char, and pike). The local police station issues permits good for a day, week, or year, and will notify you of restrictions and regulations, which can vary from one spot to the next.

Golf. There are about thirty golf courses throughout Switzerland. In the Alps, every possibility for building a golf course seems to have been explored (in St. Moritz, you can play golf all winter on a frozen lake). As a general rule, if you belong

In the Engadine, it's possible to play a game of golf and sight-see at the same time.

to a golf club in your own country, you will be admitted to one here upon payment of a small fee.

Tennis and squash. Many resorts and most big cities have tennis courts, but the city facilities are often overrun with people. Lessons are available. Every summer, the Swiss Open, the Gstaad International Championship, attracts the world's best players.

Horseback riding. There are stables and riding schools on the outskirts of major cities, as well as in vacation spots. Write the Swiss tourist office or ask a travel agent about the particulars of an "equestrian vacation."

Bicycling and mountain biking. Don't hesitate to rent a bike at the train station: you can take it back to any other station when you

get tired. Switzerland's terrain makes it an ideal place for mountain biking. Ask at the local tourist office for recommended routes; detailed maps are available as well. Remember, though: you'll need strong calves and good lungs.

FESTIVALS AND FOLKLORE

There is no Swiss village, no matter how small, that doesn't put on at least one festival a year. Regional tourist offices publish annual brochures listing all the celebrations planned for the region.

During festivals or in marketplaces, you will often hear the slow, somber sound of the alphorn, a curious wind instrument of astonishing size. Yodeling may be encountered in certain restaurants in German-speaking Switzerland as well as at festivals.

Folklore and sport meet in the ancient tradition of Swiss wrestling (*Hosenlupf*). The wrestlers, wearing special leggings, clash grimly until one of them throws his adversary into the sawdust, all according to the strictest rules. And in the Valais region, there are "combats of the queens" (cow fights) that attract crowds every Sunday in spring. See page 148 for a more complete list of Swiss fêtes.

SHOPPING

Cheeses, chocolate, and cuckoo clocks: these are the first items that shopping in Switzerland brings to mind, but there are many other possibilities.

Luxury goods, such as furs,watches, and jewels, are the best deals to be had. On the

What other souvenir would be more evocative of a trip to Switzerland than a fine clock?

Annual Festivals

January. Popular celebrations ring in the New Year. Horse races in the snow in St. Moritz and Arosa; Vogel-Gryff Day in Basel; *Silvesterklausen* in Urnäsch.

February/March. Carnival in Basel, Lucerne and other Catholic parts of Switzerland.

March. In Engadine, the *Chalanda März* (a children's procession of pagan origin) and the ski marathon (with thousands of participants).

April. Sechseläuten in Zurich: Bonfires with Old Man Winter, known locally as the *Böogg*; colorful parades. Procession of weeping women in Romont.

April/May. Landsgemeinde in Appenzell; "combats of the queens" in the Valais.

June. Herding of cows up the Alps. International Festival in Zurich (concerts, operas, theater, exhibits). Swiss costume festival in Berne.

July. Jazz festival in Montreux and Paléo festival in Nyon. East Switzerland Yodelers' Festival in Chur. Opera Festival in the amphitheater of Avenches. "Estival Jazz" in Lugano.

August. National Day. Music festivals in Lucerne and Gstaad. International film festival in Locarno. Fireworks and parades at the Geneva Days. Street Parade (techno music festival) in Zurich.

September. Music festivals in Montreux and Vevey. Swiss crafts fair in Lausanne.

September/October. Wine harvest (vendange, in French) festivals in Lugano and Neuchâtel.

November. Onion market in Berne (*Zibelemärit*). Autumn fair in Basel.

December. The Escalade historical procession in Geneva.

other hand, many everyday articles may seem expensive here, due to the strength of the Swiss franc. But the quality of the items is rarely in question, as the Swiss themselves are demanding consumers. Salespeople are generally courteous and efficient.

Look out for good buys during the sale periods of January through February and July through August. No taxes need be added: the price on the label is the price you pay.

Where to Shop

Zurich and Geneva are known all over the world for their elegant boutiques, as are Basel and Bern, and resorts such as Gstaad and St. Moritz. If your budget doesn't allow you the occasional splurge, you can find reasonable buys in department stores, where prices seldom vary from one canton to the next.

What to Buy

Liquor. Fruit brandies (*eaux-de-vie*) are easy to transport and make lovely souvenirs or gifts: they include apple, kirsch (cherry), marc (made from champagne), pear, plum, and gentian.

Antiques. Whatever you're looking for, you can find it here. Luxury antique shops and secondhand dealers are everywhere. To find silver and old jewelry or any other precious object, go to the auctions held in Zurich or Geneva. Finally, don't turn up your nose at street fairs and flea markets, where it's always possible to discover a real find.

Art. Art galleries abound, in small towns and big cities alike. Specialists in the field make sure that Swiss prices remain competitive with foreign ones, and merchants are glad to ship paintings and sculptures anywhere in the world.

Embroidery. Saint-Gall has made its reputation in the world of embroidery; look especially for napkins, tablecloths, blouses, and handkerchiefs.

Chocolate. Switzerland produces what is easily the largest variety of chocolates in the world. Milk chocolate, especially, is of the

Art and commerce converge in the reflective window of a Geneva jewelry shop.

highest quality. You will find an amazing choice of truffles in luxury chocolate shops.

Knives. The Swiss army knife—a little tool kit that fits right in your pocket—has as many as 13 pieces, from a corkscrew to a miniature saw. It can take on any task.

Cheese. Merchants can tell you which cheeses will survive the trip home, and will wrap them accordingly (see page 152).

Jewelry. Jewels (gold and precious stones) are always of the highest quality here. Gaze at the sumptuous window displays on major shopping streets, but don't neglect the tiny stores tucked into the winding streets of old towns.

Watches and clocks. From the "disposable" watch to the finest timepiece, the choice here

is immense. You can rest assured that whatever model you choose will come with an international guarantee. Above all, don't forget to bring back a Swatch, a cute and useful souvenir. If you want something a bit fancier, choose a Rolex, an Audemars Piguet, or a Blancpain.

As for cuckoo clocks, they do really exist, in every size, in department stores and souvenir boutiques. If the little bird who chirps the hours isn't serious enough for you, perhaps a pendulum clock from Neuchâtel will tempt you instead.

Souvenirs. Some local choices include cowbells, collectible dolls, and yodeling records, but there are also fossils or rocks from

the Alps, crafted objects from the *Heimatwerk* (homecraft) boutiques, wooden toys, bowls, and plates, music boxes, copper, pewter, painted Easter eggs, and landscapes or silhouettes cut out of paper.

ENTERTAINMENT

Swiss cities have a livelier nightlife than you might imagine. Even in relatively isolated places, it is not unusual to find a disco, an outdoor dance, or a concert. But it must be confessed that, in a country where work often begins at 7am, night crawlers are a rare sight.

Nightclubs that offer floor shows and orchestras only exist in the bigger cities. Elsewhere, entertainment is often limited to a piano player, but there is a certain charm in the simpler pleasures Switzerland has to offer, like sharing a good bottle of wine by a fire in a mountain chalet, or taking a "dancing cruise" on a lake.

International tours by important musical artists invariably include a few Swiss cities among their stops. Swiss chamber orchestras and symphonies, like the famous Orchestre de la Suisse Romande, often give concerts. Look into the possibility of hearing medieval music in a castle courtyard, or an organ recital in an old church. There are also frequent music festivals in the area, the most famous of which is held in Lucerne in August.

Opera and dance performances are easy to find in Zurich, Geneva, Basel, Bern, Lausanne, and Saint Gall.

Jazz, both traditional and avant-garde, is not neglected either, but all the concerts to be heard around the country during the year are just warmups for the famous Montreux Festival.

Swiss theater is well regarded everywhere; good local troupes alternate with foreign companies on tour. Every genre is represented, and the productions are of the highest quality.

In the resorts and big cities, some movie theaters show films in the original language with subtitles in French and German. Elsewhere, they are generally dubbed. The Locarno film festival has received worldwide acclaim (see page 98).

EATING OUT

The Swiss like to eat and drink well, and they offer their visitors enough choices to satisfy any taste, from the popular fare served in village bistros to the refined gourmet menus of worldclass restaurants.

Each region has its own specialties, often influenced by the traditions of the neighboring country whose language is spoken there.

Fondues and Cheeses

Fondue is more than a meal, it's a party. Guests gather around a *caquelon* (cast-iron dish) bubbling with cheese melted with white wine (with just a shot of kirsch) and, armed with long fondue forks, dip in their hunks of country bread.

Besides the familiar Gruyère fondue, there are creamier variants, such as the *moitié-moitié* (half-and-half), where the Gruyère is mixed with Vacherin cheese from Fribourg, or the Fribourg fondue, made up of Vacherin alone. There are also fondues containing wild mushrooms or tomatoes.

Those who prefer to eat meat might try a *fondue bourguignonne* (Burgundian fondue) or *chinoise* (Chinese fondue).

Raclette is a cousin of fondue. A half-wheel of cheese is placed in front of a heat source—traditionally a hearth—and when the cheese begins to melt, a portion is scraped off (from *râcler*, to scrape, hence the name). The cheese falls onto your plate next to a boiled potato, onions cured in vinegar, and tiny crisp pickles called *cornichons*.

Only white wine or hot tea should be drunk with fondue or raclette; cold drinks are said to inhibit digestion. The same is true for the delicious pastries called *malakoffs*, a kind of savory doughnut made with Gruyère.

Cheeses. These do not make up a course in themselves, as in France, but are served as hors-d'oeuvres or at late-night "suppers," accompanied by baked potatoes.

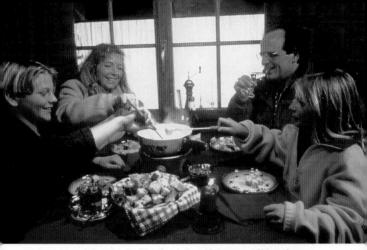

An entertaining meal of fondue is just about as traditional as you can get in Switzerland.

Emmental is a sweet cheese full of holes. Appenzell is a sharper version. The firm interior of Gruyère (*Greyerzer* in German) has only a few small holes and tastes of hazelnut. Gruyère exists in sweet, semi-salty, and salty varieties. Sbrinz, a hard cheese, is served in *rebibes* (slices as thin as cigarette paper). Firm, round, and strong-smelling *Tête-de-moine* (monk's head) is a Jura specialty. It is carved out, until it resembles a sort of fragrant mushroom. It is generally eaten in winter.

Tomme, a sweet, soft cheese from Vaud, is sometimes combined with cumin. Reblochon, a creamy cheese, is somewhat stronger. Finally, we should mention Schabziger, an herbed cheese from the canton of Glarus that smells, well, powerful: a curiosity.

For unexpected hunger pangs, take along a *ramequin* (*Chäschüechli*, in German), a small cheese pie, or perhaps some cheese toast (*Käseschnite*).

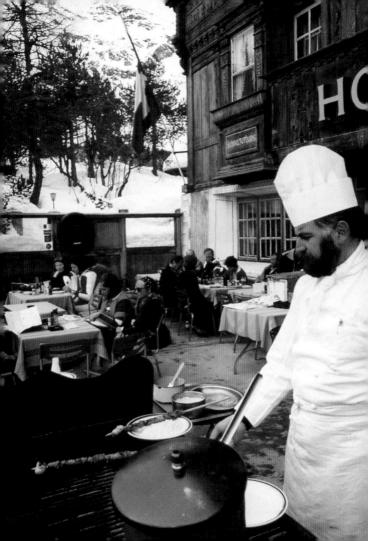

Specialties of French Switzerland

Fish. The *omble chevalier*, or knight's char, the most delicate and delicious of fresh-water fishes, is usually poached and served with Hollandaise sauce or melted butter. Trout and its pink-fleshed cousin salmon trout are both excellent. Perch is most often served fileted and fried, with tartar sauce and a slice of lemon. Pike is either grilled or prepared in *quenelles* (dumplings) while *fera* filets are baked or fried.

Meat. French influence is obvious in the *entrecôtes* (rib steaks) and filet mignons served here. *Assiette valaisienne* (Valais assortment) is made up of fine rolled slices of dried meat and bacon, smoked ham, sausages, cheese, and tiny pickles. Wonderful with rye bread and a *déci* (or two) of Swiss white wine.

Specialties of Italian Switzerland

Piccata, pasta, and *pizza.* In the Ticino, you eat like an Italian. But *risotto* here is enhanced with onions, mushrooms, and grated cheese.

Polenta, a thick corn purée, is served as an accompaniment to meat. Enriched with cream Ticino-style, it is called *polenta grassa* and restaurants stock it by the tureen. Taste these treats in a *grotto* —they can be found in the most picturesque and romantic places.

Specialties of German Switzerland

Soups. The long winters of this region make soup a highly appreciated dish. Many kinds are made here: one worth mentioning is the *Basler Mehlsuppe* (grilled flour soup from Basel), eaten early in the morning during Carnival season. There is also the *Brotsuppe* (bread soup) beloved by natives of Lucerne.

Fish. One of the best is *fera* (*Felchen*), fished from the region's many lakes. Perch (*Egli*) and trout (*Forelle*) are often raised in tanks.

On a cold winter day, a hot outdoor grill is sure to attract a flock of hungry skiers.

Rötel, which comes from the Zug lake, and *Äsche*, a cousin of trout, are only eaten in late autumn and early winter.

Meat. Geschnitzeltes Kalbfleisch (sliced veal in cream sauce) is called *Emincé Zurichoise* in French-Swiss. *Berner Platte*, or "Bern assortment," consists of beef, sausages, sauerkraut or green beans, and potatoes. *Bündnerfleisch* or Grison-style meat, is raw, air-dried beef eaten in paper-thin slices at the beginning of a meal.

Game. During hunting season, from September to February, game is a popular delicacy. The saddle cut of the roebuck (*Rehrücken*) is served with chestnuts, boiled potatoes, cranberry sauce, and red cabbage. Other wild game dishes include deer (*hirsch*), boar (*Wildschwein*), and hare (*Hase*).

Sausages. There are at least forty-five varieties of sausage, eaten boiled, fried, grilled, cold, smoked, and even in salads. *Schüblig* is a pork sausage, and *Bratwurst mit Zwiebelsauce* is veal sausage served with an onion sauce.

Side dishes. Don't leave this region without trying the *Rösti*, or grated, grilled potatoes. *Spätzli*, boiled pasta dumplings, are served with meat and game.

Desserts. Fruit pies are eaten for dessert or as snacks; some people even make a meal of them. No one can resist the *Zuger Kirschtorte*, the kirsch tart from Zug, or the *Rüeblitorte*, a cake made from carrots and eggs and topped with almonds, cinnamon, and fruit brandy. Finally, the wonderful walnut pie is a specialty of Engadine.

Along with the tiny fruits that grow so well in the mountains blueberries and raspberries, served with the rich *crème fraîche* of the Gruyère region—there are always delicious meringue desserts, served with or without whipped cream.

Swiss Wines

The great wine-growing regions of Switzerland are the cantons of the Valais, Vaud, and Geneva. In the bars and restaurants, wine can be ordered by the bottle or half-bottle, or in carafes of one or more deciliters. White wines are often remarkable here, derived mainly from the Chasselas grape, but also often from the Sylvaner (known as Johannisberg in the Valais), which makes for a sweet bouquet. The best-known and most common wine is the fruity *fendant*, but you can also find Riesling, Pinot Gris or Pinot Blanc, Chardonnay, or Dézaley, which is dry and very drinkable. Be sure to try Valais specialties like Humagne Blanc, Petite Arvine, and Amigne.

Red wines are mainly of the Gamay and Pinot Noir varieties. In the Ticino, the most prevalent wine is the robust Merlot, a strong red with a lovely ruby color. Also, try Nostrano, a heady red wine, or Mezzana, which comes in both red and white. German-Swiss wines are less well-known, but some of their light dry reds (Hallauer, Maienfelder, Klevner, and Stammheimer) are worth tasting.

Other Drinks

Swiss blonde beers are sold under many names, both bottled and draft. Like German beers, they tend to range in strength from medi-

These little treats may look like charming toys, but, actually, they're good enough to eat.

Spending the afternoon soaking up the sun in an outdoor café is a way of life in Swiss towns.

um to very strong. If you don't drink alcohol, try the local fruit juices, especially apple and grape.

Fruit brandy (*eau-de-vie*) is a common after-dinner drink. Among these liquors, which are very popular in Switzerland, try apple, prune, kirsch (in Basel and Zug), the *grappa* of the Ticino, the *poire William* of the Valais, or *chrüter* (an herbal brandy).

Coffee

At breakfast time, the customary drink is *Milchkaffee*, coffee with hot milk (called a *renversé* in French-speaking regions). The coffee here is generally less strong than that served in France or Italy. For an Italian-style espresso, ask for a *ristretto*. Coffee is always served with a small pot of cream; if you're lucky, the dish it comes in will be made of chocolate and filled with thick *crème fraîche*.

INDEX

Aare Gorges 73 Adelboden 68, 143 Allerheiligen 38 Altdorf 22,82 Am Römerholz 34, 37 Appenzell 17, 28, 38, 40-42, 143, 148, 153 Appenzeller Schaukäserei 42 Arlesheim 53 Arolla 107 Arosa 7, 88, 148 Arsenal 54, 76, 131 Ascona 28, 97-98 Augst 52-53 Avenches 14, 121, 148 Baden 28, 55 Bahnhofstrasse 29,76 Basel 17, 20, 28, 45, 51-54, 126, 128, 148, 151, 155, 158 Basler Papiermühle 51 Beckenried 81 Bellinzona 28, 94-95, 99 Bern 10, 14, 16, 18, 24, 28, 54, 61-67, 82, 94, 112, 119, 121, 149, 151, 156 Biel 28, 64-66, 121, 124 Bischöfliches Schloss 87 Blonav 115 Bosco 98 Brienz 68, 70-73 Brienzer Rothorn 71 Brig 107, 109 Brunnen 81

Bulle 122 Burg 83 Burgdorf 66 Bürgenstock 81

Campione d'Italia 102 Carouge 137, 140 Centovalli 98 Champéry 103, 141 Chur 28, 86-88, 90, 92, 148 Chutes du Rhin 39 Cimetiére de Plainpalais 132 Cimetta 96 Coppet 111 Crans-Montana 106, 141

Davos 7, 28, 87, 89-90, 141 Diavolezza 93 Disentis 89 Divonne 140 Domleschg valley 90 Dornach 53

Eiger 7, 69-70, 75 Einsiedeln 84, 86 Emmental 28, 66 Engadine 28, 84, 87-88, 90-93, 143, 146, 148, 156 Engelberg 83 Estavayer-le-Lac 124 Evolène 107

Fasnachtsbrunnen 47 Flims 86, 89, 141 Flüelen 82 Franches-Montagnes 127 Franziskanerkirche 76 Fraumünster 29, 31 Fronwagplatz 38 Furka pass 110 Fürstensaal 86

Gais 42 Gandria 101 Gerechtigkeitsgasse 59 Gerechtigskeitsbrunnen 59 Giessbach Falls 72 Gletschergarten 78 Goetheanum 53 Golden League 36 Gornergrat 71, 109 Grand-Saint-Bernard 104 Grande Dixence 107 Grandson 16, 63, 124 Grindelwald 28, 69, 143 Grossbasel 46 Grossmünster 31 Gruyères 122, 126 Gstaad 28, 68, 116, 146, 148 Guarda 90 Gurten 62

Hauptgasse 42, 54, 67 Herisau 42 Höhematte 69 Höheweg 69 Hölloch 84

Ilanz 89 Interlaken 22, 28, 56, 68, 116 island of Mainau 39 Isles of Brissago 97

Jardin Brunswick 135 Jesuitenkirche 54, 76, 80 Jungfrau 7, 66, 69-70, 75

Kandersteg 68, 107 Kapellbrücke 76 Käfigturm 57-58 Kindlifresserbrunnen 58 Kippel 107 Kleinbasel 46 Kleine Scheidegg 69 Kramgasse 58-59 Kreuzlingen 39 Kussnacht 81

La Chaux-de-Fonds 127, 133 La Côte 28, 110-111 La Majorie 106 Laax 89, 141 Lake Maggiore 28, 95, 97 Lake of Lucerne 81 Landvogteischloss 55 Langnau 66 Lausanne 14, 28, 110, 112, 114, 117, 122, 148, 151 Lälle-Keenig 46 Lenzerheide-Valbella 88 Les Diablerets 117, 144 Les Pleiades 115 Leuk 107 Leukerbad 107 Levsin 117 Lindenhof 26, 30 Locarno 28, 95, 97, 148, 151 Lötschental 107

Löwendenkmal 78 Lugano 10, 28, 98-102, 148 Madonna del Sasso 95 Maienfeld 87 Martigny 104 Matte 61 Matterhorn 7, 28, 71, 108-109 Meiringen 73 Melide 102 Mittlere Rheinbrücke 46 Mon-Repos 135 Mont-Pèlerin 115, 118 Monte Generoso 102 Monte Verità 97 Montreux 28, 112, 115, 148, 151 Morcote 102 Morges 112 Mount Brè 100 Mount Pilatus 28, 81-82 Mount Rigi 28, 82-83 Mount Rose 109 Mount Salève 136, 140 Mönch 7, 69-70, 75 Munot 39 Muottas Muragl 93 Murten 16, 120-121, 124 Museggmauer 78 Münster 38, 47, 61 Münsterplattform 61 Münsterplatz 47 Mürren 27, 70 Müstair 92 Niesen 67

Nyon 111-112, 148

Paverne 121 Perle du Lac 135 Petit Palais 136, 139 Pontresina 93, 141, 144 Porrentruy 128 Portes du Soleil 103, 141 Rapperswil 35 Reichenau 89 Reichenbach Falls 73 Ring 58, 65, 148 Riva San Vitale 102 Rochers-de-Nave 116 Rolle 112 Romainmôtier 126 Romont 122, 148 Ronco 98 Rorschach 39 Rütli 24, 81, 136, 138 Saas-Fee 28, 71, 109, 141, 144 Saignelégier 127

Obergasse 65, 83 Oberhofen 67

Ouchy 112-114

139 - 140

Papiliorama 123

Palais des Nations 134, 137,

Saignelegier 127 Saint Maurice 104 Saint Peter's Island 66 Saint-Gall 28, 39-41, 149 Saint-Gervais 136, 139 Saint-Ursanne 127 San Lorenzo 99 Santa Croce 102 Santa Maria degli Angioli 99

Säntis 42 Schantzengraben 36 Schloss Thun 67 Schynige Platte 69 Schywz 83 Scuol 90, 144 Simplon pass 109-110 Sion 28, 103, 105-107, 116 Solothurn 17-18, 23, 28, 45, 54 Sonogno 98 Spalentor 47 Spiez 67-68 Spitalgasse 57 Splügen 90 Spreuerbrücke 76 St. Moritz 7, 87, 92-94, 141, 143, 145, 148-149 Stein 28, 36, 39, 42 Stein am Rhein 28, 36, 39 Swiss National Park 90 Swissminiatur 102 Taubenloch gorges 65 Technorama 34, 37 Tellskapelle 82 Thun 28, 67-68, 70 Titlis 83 Trogen 42 Trun 89 Trümmelbach Waterfalls 70 Untertorbrücke 59 Urania 29 Urnäsch 42, 148

Val d'Anniviers 107 Val d'Herens 107 Val Verzasca 98 Valère 106 Valle Maggia 98 Vaud Riviera 28, 114 Verkehrshaus der Schweiz 79 Vevey 112, 115, 148 Via Mala 90 Vierwaldstättersee 22, 79, 81-82 Villa Favorita 99 Villa Le Corbusier 115 Villa Malpensata 100 Villars-sur-Ollon 118 Vitra Design Museum 51-52

Wasserkirche 31 Wasserturm 76 Weggis 81, 83 Wetterhorn 69 Winterthur 34, 36, 38 Witznau 81

Yverdon-les-Bains 124

Zeitglockenturm 54 Zermatt 28, 71, 93, 109, 141, 144 Zernez 90 Zillis 90 Zoologischer Garten 34, 48, 52 Zug 16, 18, 73, 83, 156, 158 Zuoz 92, 96 Zürichhorn 33-34 Zürichsee 35 Zygloggeturm 58 Zytturm 83

Handy Travel Tips

HANDY TRAVEL TIPS

An A-Z Summary of Practical Information

- A Accommodations 164 Airports 165
- **B** Babysitting 166 Budgeting for Your Trip 166
- C Climate 166 Clothing 167 Complaints 167 Crime and Safety 167
 - Customs and Entry Formalities 167
- **D** Driving in Switzerland 168
- E Embassies and Consulates 171 Emergencies 171
- **G** Getting There 172
- H Hairdressers 174 Health and Medical
- L Language 175 Laundry and Dry Cleaning 175

Legal Holidays 176 Lost Property 176 **M** Maps 177 Media 177 Meeting People 178 Money Matters 178 O Open Hours 179 P Police 180 Post Office 180 Public Transportation 181 R **Religious Services 184** Restaurants 184 Т Telephone 187 Time Zones 188 Tipping 188 Toilets 188 **Tourist Information** Offices 188 **U** Useful Expressions 190 W Weights and

Measures 191

A

ACCOMMODATIONS

Hotels of all categories are listed in the *Swiss Hotel Guide*, published annually by the Swiss Hotel Association (Monbijoustrasse 130, 3001 Bern; Tel. 031/370-4111). This association also prints a number of leaflets with information concerning families, senior citizens, and facilities for the disabled. You can find these and other booklets of hotel listings at Swiss National Tourist Offices abroad and at many travel agencies.

Local tourist offices can tell you what type of accommodations are available (hotels of every category, pensions with full or partial board, and apartment-hotels offering rooms, studios, or apartments).

Hotels of all classifications in Switzerland are usually very clean and comfortable. Prices are generally per person (tax, breakfast, and service included). You must show your passport and fill in a form when registering.

Private rooms. Tourist offices will provide you with a list of rooms for rent in private homes — the Swiss equivalent of bed-and-breakfast establishments. You can also knock on the door of houses advertising a "room for rent" (*chambre à louer/Zimmer zu vermieten/camere da affitare*).

Chalets and apartments. To rent a chalet or apartment, ask a travel agent at home or in Switzerland, check with the tourist information office (they have detailed brochures for well-traveled regions), or look in the classified ads.

Youth hostels (auberge de jeunesse/Jugendherberge/ostello della gioventù). There are more than 80 youth hostels throughout the country: there is no age limit, but those under 25 have priority. Reservations are recommended during the high season. For a complete list of hostels and their rules, write to: Schweizer Jugendherbergeren Zentralsitz, Schaffhauserstrasse 14, 8006 Zurich; Tel. (01) 360-1414.

Camping. Several hundred campgrounds, some in the Alps, are approved by the Swiss Camping and Caravan Association. Ask for the Swiss camping guide at a local Swiss tourist office (see TOURIST INFORMATION OFFICES), at the Swiss Touring Club, Camping Division, Chemin de Blandonnet 4, 1214 Vernier (Tel. 022/417-2727), or at bookstores.

Handy Travel Tips

I would like single/double room with bath/shower. What is the rate per night?

J'aimerais	Ich möchte te	Vorrei
une chambre à un	ein Einzelzimmer/	una camera
lit/ deux lits	Doppelzimmer	singola/doppia
avec bains/douche.	mit Bad/Dusche.	con bagno/doccia.
Quel est le prix	Was kostet eine	Quanto costa per
pour une nuit?	Ubernachtung?	notte?

AIRPORTS (Flughafen/Aeroporto)

Switzerland's three major international airports are, in order of importance: Zurich-Kloten, Geneva-Cointrin, and Basel/Mulhouse. Swissair, the national airline, provides frequent flights between these airports, and there are convenient rail connections as well. The airports of Bern and Lugano are smaller, but still offer some direct flights to other countries.

The terminals in Zurich, Geneva, and Basel have all the usual modern amenities: snack bars, restaurants, newsstands, car rental agencies, banks, post offices, stores, and duty-free shops. Luggage carts may be found in the check-in and baggage-claim areas.

Ground transport. A regular train service makes the 10-minute trip from Zurich-Kloten airport to the city's main train station four or five times an hour.

From Geneva-Cointrin, there are six departures an hour to the Gare Cornavin, the main railway station in downtown Geneva, a 6-minute trip. Trains also run four or five times an hour to Lausanne.

The Basel, Bern, and Lugano airports provide a shuttle bus connection to the city center with departures every half hour (there are direct pickups at each airline).

Fly-Rail baggage service. If you're departing from Zurich, Geneva, or Basel on a scheduled or charter flight, you can register baggage all the way to your final destination at many Swiss railway and postal bus stations. You will generally be required to drop off your baggage 24 hours in advance. Some large railway stations (23 in all) also have a check-in station and will issue you an airline boarding card (this service is included in the price of sending your bags). The fee is well worth it, considering the aggravation saved. This service is also available upon your arrival in Switzerland.

B

BABYSITTING

The hotel concierge or any local tourist office can help you find a reliable babysitter. Many resorts have nurseries to watch small children while you ski. In big cities, some department stores have a play area for children.

BUDGETING for YOUR TRIP

Switzerland has a reputation as an expensive country. Given the strength of its currency and the extensive development of its tourism industry, prices are generally comparable to those in major tourist destinations elsewhere in Europe. Prices are higher in fashionable resorts, as well as in big cities like Geneva and Zurich, but they vary relatively little from one region to the next. To give you an idea, here are some average prices, given, of course, in Swiss francs (FS). While the inflation rate in Switzerland is low, keep in mind that these prices must be regarded as approximate.

Bus. 1.50 francs (3 stops), 2 francs plus (4 or more stops). Day passes 5 francs.

Bicycle rental. 25 francs (24 hours).

Ski equipment rental. Cross-country 25 francs/day, 100/week. Downhill skiing, 30 and up/day, 120–150/week.

Meals and drinks. Breakfast 12 francs, lunch (in a good restaurant) 18–35 francs, daily special 12–16 francs, dinner 25–45 francs, fondue 16–18 francs, coffee 2.90 francs, draft beer (½ liter) 3.20 francs, bottle of wine (½ litre) 12–17 francs, non-alcoholic drinks 3–3.50 francs.

Swiss Pass (second class). 216 francs (4 days), 270 francs (8 days), 314 francs (15 days), 430 francs(1 month).

CLIMATE

In general, Switzerland's climate is continental. The winters are cold and snowy (especially in the mountains); the summers are hot with occasion-

Handy Travel Tips

al storms. Here and there, the existence of a local microclimate makes for a change in the general pattern. Spring tends to be cool and unpredictable, with autumn usually stable and mild. All year long, temperatures can change from one extreme to the next within a few hours, a few miles, or a few hundred feet of altitude. It may be pouring rain in northern Switzerland and perfectly sunny in the Ticino or Engadine.

CLOTHING

In view of the unpredictable weather patterns, it's best to be ready for anything. In summer, don't forget to take along a raincoat and umbrella, as well as a jacket or sweater. In winter, bring a warm coat and lined, waterproof snow boots for the mountains.

The Swiss generally dress conservatively in subdued colors and modest styles. In smart restaurants, theaters, and classical music venues, you may feel out of step without a coat and tie or a nice dress, but the younger generation tends to prefer simple, casual clothing.

COMPLAINTS

The Swiss tourist industry, proud of its competence and courtesy, takes all customer complaints seriously. A word to the hotel or restaurant manager should sort out any problems. However, if you can't reach a satisfying arrangement, address your grievance to the local tourist office or the Swiss Hotel Association (see ACCOMMODATIONS).

CRIME and SAFETY

Muggings and violent crimes are rare in Switzerland, where you can come and go, day and night, in peace. But burglars and pickpockets can strike in any country, so it's always wise to lock your car and put your valuables in the hotel safe.

In winter, keep your skis in a safe place: they can easily disappear from car roof racks and the entrances to après-ski spots.

CUSTOMS and ENTRY FORMALITIES

Most visitors — including citizens of Britain, the US, Canada, and the majority of other English-speaking countries — need only a valid passport to enter Switzerland. British subjects can use the simplified Visitor's Passport. You are entitled to stay for up to 90 days without further formality.

Into:	Cigarette	S	Cigars		Tobacco	Alchol		Wine
Switzerland	200	or	50	or	250 g	1l	and	21
	(400)*		(100)*		$(500g)^*$			
Australia	250	or	250g	or	250g	tota	l of 1	125ml
Canada	200	and	50	and	1kg	1.1l	or	1.1l
Ireland	200	or	50	or	250g	1l	or	2l
New Zealand	1 200	or	50	or	250g	1.1251	or	4.51
South Africa	400	or	40	or	400g	1l	or	1l
UK	200	or	50	or	250g	1l	and	2l
US	200	and	100**	and	***	1l	or	1l

The following chart shows which duty-free items you may take into Switzerland and, when returning home, into your own country:

* The figures in parentheses are for non-European visitors only.

** No Cuban cigars ***A reasonable quantity

Monetary restrictions. There is no restriction on the import or export of either Swiss or foreign currencies.

DRIVING in SWITZERLAND

Rental. To rent a car you must produce a valid driver's license, held for a minimum of one year. You must be at least 25 years old. You can rent a car at many railway stations. Agencies usually waive cash deposits for clients with recognized credit cards.

Driving your own car. To bring your car into Switzerland, you'll need a national driver's license, car registration papers, and your Green Card (a recommended but not obligatory extension to your regular car insurance policy, validating it for foreign countries).

A nationality code sticker must be visible at the rear of your car, and you must have a red warning triangle reflector for use in case of a breakdown. Seat belts are obligatory both in town and in the country. In winter you may be required to use snow chains on Alpine passes. These can be obtained at gas stations along the way.

On the road. Drive on the right and give priority to the right unless otherwise indicated. On mountain roads, leave the awesome views to the passengers; to admire the scenery in safety, stop at roadside parking areas. On difficult stretches of mountain roads, right-of-way is given to postal buses,

or otherwise to the ascending vehicle. Honking your horn is recommended on blind corners of mountain roads; avoid it everywhere else.

In general roads are good, and there is a well-developed highway network linking all the big towns.

Highway tax. An annual road tax of 40FS is levied on all cars and motorcycles using Swiss highways. An additional fee of 40FS applies to trailers and caravans. The *vignette* (sticker) is valid from 1 December of the year preceding the date stamped on the vignette to 31 January of the following year.

The vignette can be purchased from customs officers at border crossings and is good for multiple re-entry into Switzerland throughout its period of validity.

Speed limits. On the green signposted highways (*autoroute/Autobahn/ autostrada*), the maximum speed is 120 km/h (75 mph). On other roads the limit is 80 km/h (50 mph) unless otherwise indicated. In residential areas the speed limit is generally restricted to 50 km/h (31 mph), although you might encounter sections posted at either 60 km/h (37 mph) or 30 km/h (19 mph). Cars towing caravans and trailers may not exceed 80 km/h (50 mph), even on highways.

Car trouble. If your car breaks down, call the TCS or Swiss Touring Club (*Touring Club Suisse/Touring-Club Schweiz/Touring Club Svizzero*). It is also a good idea to contact an international insurance company before leaving to cover costs; otherwise, you will be responsible for the full price of paying a mechanic or tow truck. You can get help at any public telephone by dialing 140.

Emergency telephones are installed at regular intervals along highways.

Parking. Try to avoid parking in congested central shopping zones or historic city centers. Most cities have adopted a system of parking meters or "blue zones" (*zone bleu/Blaue Zona/ zona blu*) and "red zones" (*zone rouge/Rote Zone/zona rossa*), which limit parking time to, respectively, an hour and a half and 15 hours. To park in these zones, marked with blue or red paint, you must display a parking disc (*disque de stationnement, Parkscheibe/disco orario*) on the dashboard indicating when you left your car. The discs are given out free of charge at gas stations, banks, and police stations. Paid parking lots are also widely available. Rarely seen "white zones" allow for unlimited parking.

Road signs. Most signs in Switzerland conform to international norms. Here are the translations for some common signs:

Exit Airport Icy Road Downtown Detour Customs	Sortie Aéropo Verglas Centre Déviati Douan	s -ville ion	Ausfart Flughafe Glatteis Stadtzen Umleitun Zoll	trum	Uscita Aeroporto Strada ghiacciata Centro città Deviazione Dogana
Some useful ex	pressio	ons:			
driver's license permis de condu	ire	Führerat	usweis	licenza	di condurre
car registration Carte grise/perm de circulation	• •	Fahrzego	usweis	licenza	di circolazione
Fill the tank, plo Le plein, s'il vou		Volltanke	en, bitte.	Il pieno	, per favore.
I've had a break	kdown.				
Ma voiture est en panne.		Ich habe Panne		Ho avu	to un guasto.
There's been an accident.					

Il y a eu un accident.	Es ist ein	C'è stato un incidente.
	Unfall passiert.	

Fluid measures

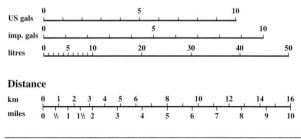

EMBASSIES and CONSULATES

(Botschaft; Konsulate/Ambasciata; Consolato)

All embassies, located in Bern, have their own consular sections (for passport renewal, visas, etc.) Some countries also maintain consulates in Geneva, Zurich, and other cities. Below are the addresses for the diplomatic outposts of some English-speaking countries:

Australia	Consulate General: Chemin des Fins 2, PO Box 172, 1211 Geneva 19; Tel. (022) 799-9100
Canada	Kirchenfeldstrasse 88, 3005 Berne; Tel. (031) 357-3200
Ireland	Kirchenfeldstrasse 68, 3005 Berne; Tel. (031) 352-1442. <i>Consulate:</i> Claridenstrasse 25, PO Box 562, 8027 Zurich; Tel. (01) 289-2515
New Zealand	Mission and Consulate General: Chemin des Fins 2, 1218 Grand-Saconnex, Geneva; Tel. (022) 929-0350
South Africa	Alpenstrasse 29, 3006 Berne; Tel. (031) 350-1313. Consulate: Rue du Rhône 65, 1204 Geneva; Tel. (022) 849-5454
UK	Thunstrasse 50, 3005 Berne; Tel. (031) 359-7700. Con- sulate: Rue de Vermont 37-39, 1202 Geneva; Tel. (022) 918-2400. Vice-Consulate: Minervastrasse 117, 8032 Zurich; Tel. (01) 383-6560
US	Jubiläumsstrasse 93, 3001 Berne; Tel. (031) 357-7011, (031) 357-7234. <i>Consulate:</i> Route de Pregny, 1292 Chambésy (Geneva); Tel. (022) 798-1605. <i>Consulate:</i> Dufourstrasse 101, 8008 Zurich; Tel. (01) 422-2566

EMERGENCIES (urgences/Notfall /Emergenza)

All emergency numbers can be found in any phone booth or phone book.

Here are a few of the most important:

Police	117
Fire	118

Roadside assistance	140
Paramedics, ambulance	144

If in doubt, dial 111. The operator will direct you.

For the name and address of a pharmacy (*pharmacie/Apotheke/farmacia*), doctor, or dentist on 24-hour duty, consult the daily local paper. The addresses of pharmacies open on Sundays and holidays are posted in the window of all other branches (see also EMBASSIES AND CONSULATES OR HEALTH AND MEDICAL CARE).

6

GETTING THERE

By plane

Listed below is some basic information about the frequency of flights into Switzerland's travel hubs. As airlines are constantly changing and expanding their service, check with your travel agent for the most up-todate information regarding flights into Switzerland.

From North America

New York–Zurich: 2–3 flights a day New York–Geneva: 1 flight a day New York–Basel: once a day except Wednesdays Montreal–Zurich: four times a week, not Thursday or Saturday Toronto–Zurich: once a day

From Great Britain and Ireland

London–Basel, Zurich, Geneva: 10–12 flights a day London–Lugano (via Basel): 2 flights a day London–Berne: 3 flights a day Manchester–Zurich, Geneva, Basel: several daily, not Sundays Birmingham–Zurich: 1–2 flights a day Birmingham–Geneva: 2 flights a day Dublin–Zurich and Geneva: 1–2 flights a day

From the Southern Hemisphere

Australia–Switzerland: daily flights with one change New Zealand–Switzerland: daily flights with one change South Africa–Switzerland: direct flights 5 days a week Within Switzerland. An air shuttle links Geneva and Zurich (45 minutes, 15 flights per day), Geneva and Basel (40 minutes), and Geneva and Lugano (55 minutes, 6 flights a day); there are many daily flights between Bern and Lugano (45 minutes), Basel and Lugano (50 minutes), Zurich and Lugano (50 minutes, 8 flights a day), and Zurich and Basel (30 minutes).

Discounts and special fares. Offers vary from one travel agent or airline to another. Ask about special fares. Swiss consulates abroad can guide you to agencies specializing in travel to Switzerland.

Package trips. There are any number of options for fixed-price travel. Your travel agent can tell you about packages that include your flight, hotel or apartment, and car rental, à la carte trips, trips with train fare and hotel included, driving trips, and "theme" trips (art, sports, etc.)

By train

From Great Britain and Ireland. The journey from London to Paris aboard the *Eurostar* high speed train (also known as a TGV or *train à grande vitesse*) takes 2 hours and 10 minutes via the Channel Tunnel. It then takes another 4 hours by TGV to get to Switzerland. Check arrival and departure locations in Paris: you may have to change train stations there.

From Paris, there are 5 or 6 TGVs to Geneva a day, and 4 or 5 a day to Lausanne. On the Lausanne line, there is an easy transfer at Mouchard for Neuchâtel and Bern. The Paris/Belfort line also goes to Bern through Delémont. Also, there is a TAC train between Paris and Evian. The Paris/Basel line leaves several times a day; finally, the *Arbalète* train has direct cars for Zurich.

From Spain, there is one day train, the *Catalán Talgo*, and one night train to Geneva via Narbonne and Avignon leaving from Vintimille. There is also one direct day train between Nice and Geneva.

By car

The itineraries noted here, usually on highways, are the fastest and most comfortable routes, despite the occasional extra kilometers or costs. Travel time corresponds to the average trip taken in normal traffic conditions. You can also contact your country's Touring Club before traveling to get more detailed information.

Book passage on car ferries well in advance. Fares are cheaper for midweek sailings, and the price fluctuates seasonally. The best route is

from Calais-Rimes-Chaumont-Basel-Zurich, or from Calais/Bologne-Paris-Geneva.

Regular coach service between London's Victoria Station and Geneva operates four times a week. The trip takes roughly 16 hours.

From Belgium. From Brussels to Geneva via Sterpenich (A6), Bourgen-Bresse (A39), and St.-Julien (A40/A401) is 812 km/507 miles (8 hours 50 minutes). Between Brussels and Zurich via Luxembourg, Sterpenich (A6), Strasbourg (A4), and Basel–St.-Louis is a total of 665 km/415 miles (7 hours 40 minutes).

From France. Paris and Geneva are 538 km/336 miles (6 hours 10 minutes) apart via Beaune-Nord (A6/A31) and St.-Julien (A40-A401). From Paris to Lausanne is a trip of 533 km/333 miles (6 hours 20 minutes) via Beaune-Nord (A6/A31) and Vallorbe (A9). Paris/Zurich is a distance of 650 km/406 miles via Beaune-Nord (A6/A31), Belfort (A36), and Mulhouse/Basel–St.-Louis (A2). Nice/Geneva: 547 km/342 miles (6 hours 40 minutes) via Menton/Grimaldi (A8/A10), Turin (A5), Aosta, Annemasse (A40), and Thonex. From Nice, Digne, and Sisteron, you can also reach Geneva by the Napoleon highway (Gap) or the Alpen route (Croix-Haute pass) in Grenoble; take the A41 highway to the border of Switzerland.

HAIRDRESSERS (coiffeur/Coiffeur/parucchiere)

In major cities and resorts, there are always excellent hairdressers and stylists. Note that most salons are closed on Mondays. See also TIPPING and BUDGETING FOR YOUR TRIP.

HEALTH and MEDICAL CARE

Most major tourist resorts have clinics, and all cities are served by modern, well-equipped hospitals. The standard of treatment is high, especially when it comes to ski-related injuries. But health care can be very expensive, so ask your insurance company or your travel agent if you are covered abroad. If not, think about getting a policy that will cover you for the length of your trip.

Handy Travel Tips

For more benign ailments, see a pharmacist, who will dispense medication, and suggest a doctor if necessary (see also EMERGENCIES).

I need a doctor/a dentist.

Il me faut un	Ich brauche einen	Ho bisogno di un
médecin/un dentiste.	Arzt einen Zahnarzt.	medico/un dentista.

I have a sore throat/a fever.

J'ai mal à la gorge/	Ich habe Halsweh/	Mi fa male la gola/
de la fièvre.	Fieber.	Ho la febbre.

LANGUAGE

Switzerland has four national languages: German, French, Italian, and Romansh. Swiss German, or Schwyzerdütsch, spoken by nearly twothirds of the Swiss population (in the north and the center of the country), groups a number of dialects which are often incomprehensible to a speaker of High German. Hochdeutsch, or literary German, which German-speaking Swiss learn in school, is like a foreign tongue to them.

Italian is spoken only in the Ticino (in the south) and in some parts of the Grisons. Scwyzerdütsch and Romansh are also spoken in certain parts of these regions. Romansh comes from low Latin, and includes several dialects.

French is spoken mainly in the western part of the country but is understood everywhere.

The Swiss tend to be good at learning foreign languages and often speak two, three, or even four languages. Many people speak English well enough to help you find your way around.

Do you speak English?

Parlez-vous anglais? Sprechen Sie Englisch? Parla inglese?

LAUNDRY and DRY CLEANING (blanchisserie; teinturerie/ Wäscherei; Chemische Reinigung/lavanderia; lavaggio a secco)

Most hotels provide reliable laundry and dry cleaning services. Professional launderers and dry cleaners are easy to find in the larger resorts and cities, less so in smaller resorts. Self-service laundromats are the exception, not the rule.

LEGAL HOLIDAYS (jours de Feiertage/feste)

The holiday calendar varies from one canton to the next, according to the local history and religious traditions. Here, we give you the official Swiss holidays, observed all over the country unless noted otherwise:

New Year (1 January)	Nouvel An	Neujahr	Capodanno
Christmas (25 December)	Noël	Weihnachten	Natale
St. Stephen's Day* (26 December)	Saint-Etienne	Stefanstag	Santo Stefano
Movable Dates:			
Good Friday	Vendredi-Saint	Karfreitag	Venerdì Santo
Easter Monday*	Lundi de Páques	Ostermontag	Lunedì di Pasqua
Feast of the Ascension	Ascension	Auffahrt	Ascensione
Monday of Pentecost*	Lundi de Pentecôte	Pfingstmontag	Lunedi di Pentecoste

*Holidays celebrated in nearly all cantons

On holidays (including, usually, 2 January), banks and stores stay closed all day. On the Swiss National Day, 1 August, everything is closed; the same is true for 1 May in certain cantons. Catholic cantons also observe the day of the Immaculate Conception (8 December).

Are you open tomorrow?

Ouvrez-vous demain? Haben Sie morgen offen? È aperto domani?

LOST PROPERTY

If you have lost something, check first with your hotel reception desk, then report the loss to the nearest police station. Every city has a lost-andfound office (*bureau d'objets trouvés/Fundbüro/Ufficio oggetti smarriti*). Given the Swiss reputation for honesty, there is a good chance you will recover your lost item.

You can reclaim articles left behind on trains or buses at the railway or public transportation lost-and-found office.

Handy Travel Tips

I've lost my wallet/my purse/my passport.

J'ai perdu mon porte-monnaie/ mon sac à main/ mon passeport. Ich habe mein Porte-monnaie/meine Handtasche/meinen Pass verloren. Ho perso il portafoglio/la borsetta/ il passaporto.

M

MAPS

Bookstores, stationery shops, and some newspaper stands offer a wide selection of road and regional maps, as well as city maps. Hiking enthusiasts will find indispensable topographical maps at local or regional tourist offices. Switzerland's well-maintained footpaths are also well-marked with yellow blazes and signposts that display the average time for a given hike.

Tourist offices, car rental agencies, and the larger banks also distribute excellent city maps.

Note that the maps in this guide were done by Artelius Design.

city map	un plan de ville	ein Stadtplan	una pianta della città
road map	une carte routière	eine	una carta stradale
		Strassenkarte	

MEDIA

Newspapers. Even in small towns, newsstands stock a surprisingly ample variety of foreign papers, plus all the Swiss newspapers. The best selection and earliest delivery are offered by main railway stations and airports. The English-language daily newspapers like the *International Herald Tribune* (edited in Paris), *USA Today, Wall Street Journal Europe*, and *European Financial Times* (printed in Frankfurt) are available on the day of issue.

Magazines. There are several monthly magazines published in Switzerland, including *Swiss News* and *Swiss Review of World Affairs*. English-language magazines of all kinds are widely available. In most large towns you will find English-language bookshops. Any serious bookshop will offer at least a small selection of English-language paperbacks.

Television and radio. Most of Switzerland (75% of homes and many hotel rooms) is wired for cable TV, receiving up to 35 TV stations and approxi-

mately 30 radio stations (satellite TV is not common, however). There are four Swiss cable TV stations (in French, German, and Italian, which can be tuned in without cable as well), plus German, Austrian, and Italian stations. Some of the programs are dual-language broadcasts, showing films in French, German, or Italian and the original language, which is very often English. English-language cable TV stations available in Switzerland include NBC Superchannel, CNN International, Eurosport, MTV Europe, and BBC World. Cable radio stations usually include BBC World Service and BBC Foreign Language Service, Sky Radio, Voice of America, and Swiss Radio International English Service (based in Berne, transmits via short-wave) plus a number of FM stations from Switzerland (both local, like World Radio in Geneva, and national). Depending where you are, you might be able to pick up networks from Germany. Austria, France, and Germany

MEETING PEOPLE

While very courteous, the Swiss are a rather reserved people, so it may take some perseverance to make contact with them. Although mountain or country people may seem guarded, citizens of larger Swiss cities, in any public place, often show great kindness and patience.

When you enter an office or shop, don't forget to greet the people inside. Remember the Swiss German expression *Grüezi (mitenand)*, which means roughly "Good morning (everyone)." In Italian, you can say *buon* giorno (good morning) or *buona sera* (good evening). When you leave, say *adieu (mitenand)*, or *arrivederci* if you are in the Ticino. In response, you may hear *Uf wiederluege* (until next time) or *a presto* (until soon).

In social as well as business situations, punctuality is of foremost importance. If you are invited to "dinner" in a Swiss home, don't forget to ask the hour... Swiss dinner (diner) corresponds to our lunch. The evening meal, known as supper (*souper*), is served between 7 and 9pm.

To get to know the true Switzerland, sit down in a *pinte* (bar), where locals come to drink "a couple of *décis*" (Zweierli) of white or red wine (here, open bottles of wine are ordered by the deciliter). The other customers may play *jass* (a card game) or exchange the latest gossip. In any French-speaking location, you will be amazed by the variety of "Swiss accents."

MONEY MATTERS

Currency. The monetary unit of Switzerland is the Swiss franc (franc suisse/Schweizer Franken/franco svizzero), abbreviated as F, Fr, or FS. It is divided into 100 centimes (*Rappen/centesini*), abbreviated Rp. in German and ct. in French or Italian.

Coins: 5, 10, 20, and 50 centimes (½ franc); 1, 2, and 5 francs (the 5-franc coin is often called *cent sous*).

Bills: 10, 20, 50, 100, 200, and 1,000 francs.

Banks. Most banks are open weekdays 8:30am to 12:30pm and 1:30 to 4:30, 5, or 5:30pm. Main branches generally remain open during the lunch hour. One day a week, branches keep slightly later hours, until 6 or 6:30pm; the day varies from town to town. Currency exchange offices at airports and the larger railway stations do business from around 6:30am to 7:30pm every day of the week. There is no charge to change Swiss or foreign money, buy or sell travelers' checks in different currencies, or cash Eurochecks. A money-changing machine at the Zurich airport takes notes in five currencies: French, German, Italian, British, and American. ATM machines can be found nearly everywhere and accept all cards in the EC network.

Credit cards. Smaller businesses don't like to deal with credit cards, but they're widely accepted in major establishments; you'll find signs prominently displayed at the entrance.

Travelers' checks and Eurochecks. The well-known international checks are generally accepted everywhere. The exchange rate for travelers' checks is better in banks than elsewhere. You must show your passport when cashing a travelers' check.

Do you accept travelers' checks?

Acceptez-vous les	Nehmen Sie	Accetta assegni
chèques de voyage?	Reiseschecks?	turistici?

Can I pay with a credit card?

Puis-je payer avec Kann ich mit dieser **Posso pagare con** cette carte de crédit? Kreditkarte bezahlen? **questa carta di credito?**

0

OPEN HOURS

Most offices are open from 8am or even earlier until noon and from 1:30 or 2pm until 5pm (sometimes 6pm), Monday through Friday.

Department stores and most other shops open at 8am (some at 8:30 or 9am) and remain open until 6:30 or 7pm. Some neighborhood or village grocery stores open at 7am and close for lunch, as do most boutiques, except in the larger cities. In some cities, closing time is extended until 9pm one night per week. Some businesses close for a half-day during the week — often either Monday morning or Wednesday, Thursday, or Saturday afternoon. On Saturdays, many shops open nonstop from around 8am to 4, 5, or 5:30pm, depending on the region. Finally, on Sundays, everything closes except for a few food stores (which stay open all or part of the day). In ski resorts during the high season, boutiques are open seven days a week.

Museum hours vary considerably, but in general they are open to the public Tuesday through Sunday from 10am to noon and from 2pm to 5 or 6pm. (See also MONEY MATTERS, POST OFFICE, and TELEPHONE.)

POLICE (*Polizei/polizia*)

P

Switzerland does not have a uniformed federal police. Law and order is the responsibility of the individual cantons and communities, so police uniforms vary greatly from one place to the next. Police are armed, efficient, and courteous. Law enforcement is strict.

The emergency telephone number for the police is 117.

Where is the nearest police station?

Où est le poste de	Wo ist die nächste	Dove si trova il posto
police le plus proche?	Polizeiwache?	di polizia più vicino?

POST OFFICE

In addition to normal postal business, post offices (*bureaux de poste/Post/ufficio postale*) handle telegrams and bill-paying. They are generally open from 7:30am until noon and from 1:30pm until 6 or 6:30pm, depending on the size of the office, and from 7:30 to 11am on Saturday mornings. In big cities, the main post office stays open at lunchtime, and a window reserved for urgent mail stays open until 10pm, sometimes later. In smaller towns, hours may vary; they are posted at the entry.

You can also buy stamps at machines outside the post office or in the train station, in newsstands, tobacco shops, souvenir shops (since they sell postcards), or at the hotel. Swiss mailboxes are yellow.

If you don't know in advance where you will be staying in Switzerland, you can have your mail addressed to the general delivery desk (*poste restante/postlagernd/fermo posta*) at the main post office of any town you expect to visit. You'll have to show your passport when collecting your mail.

You can send a telegram from any post office. If you prefer to send it by telephone, dial 110 (a 24-hour service).

express mail	par exprès	Express	espresso
registered letter	en recommandé	Eingeschrieben	raccomandata
a stamp	un timbre	eine Briefmarke	un francobollo

I would like to send a telegram to...

J'aimerais envoyer	Ich möchte ein	Vorrei mandare un
un télégramme à	Telegramm nach	. telegramma a
	aufgeben.	

PUBLIC TRANSPORTATION

Train

(See also GETTING THERE.) Both the Swiss Federal Railways (CFF/SBB/FFS) and smaller private railways live up to the reputation of the Swiss: service is fast, clean, comfortable, and punctual, though heavy snowfalls may cause delays. Trains run at regular intervals, with hourly service generally provided between all major cities. Intercity trains are air-conditioned, with first- and second-class cars. In addition, they offer "family cars" equipped with game rooms where children can play during the trip, and "quiet cars," reserved for passengers who prefer peace and quiet. Train schedules are posted in every station and listed connecting trains are always guaranteed. Tickets can be purchased from ticket windows or automatic machines and will be punched on the train by a ticket collector.

Train passes

There are several systems of passes good for train travel throughout Switzerland:

• The Eurailpass in all its categories (Eurail Youthpass, Eurail Saverpass, Eurail Flexipass, Eurail Flexipass Youth, and Eurail Saver Flexipass) is available only to non-European residents. It is issued in the holder's home country.

• The **Inter Rail** pass comes in three categories according to age (adults, under 26, and children ages 4–11). A fourth category, the **Euro Domino** option, is specially designed for people living in Europe, including Switzerland. These cards are available at all train stations and many travel agencies.

• The Swiss Travel System (STS) offers two excellent deals, the Swiss Pass and the Swiss Card, for individual trips that combine several different means of transportation. These practical and economical tickets are available to anyone living outside Switzerland. The Swiss Pass allows unrestricted rail, postal bus, or boat travel for periods of 4, 8, 15, or 30 days. Trams and buses in 35 cities are also included, as are discounts of 25% on most mountain trains and panoramic routes. The Swiss Flexi Pass is valid for travel on any three days within a 15-day period and includes the same reductions that are available with the Swiss Pass. The Swiss Card offers you one month of half-price travel by train, postal bus, or boat (including a special discount of 25% to 50% on most mountain trains), in addition to free round-trip connections between the airport or border train station and the town you are traveling to).

With the **Family Pass**, children under 16 accompany their parents free of charge.

Apply for the passes at travel agencies or Swiss tourist offices abroad. You can also get STS passes in any of Switzerland's major railway stations, as long as you show your passport (see also TOURIST INFORMATION OFFICES and BUDGETING FOR YOUR TRIP).

In Switzerland, contact:

- Schweizerische Bundesbahnen, Incoming Services, Postfach, 8058 Zurich Flughafen; Tel. (05) 1222-7330; fax (01) 813-0330, e-mail: incoming@sbb.ch
- · Swiss Federal Railways Travel Bureau at the Zurich Airport
- Swiss Federal Railways Travel Bureau at the Geneva Airport; website: www.cff.ch
- Rail Service; Tel. 157-2222

first/second class

première/seconde classe erste/zweite Klasse prima/seconda classe

one-way/round-trip

aller simple/aller-retour *einfach/retour*

andata/andata e ritorno

Where is the nearest bus stop?

Où est l'arrêt de bus	Wo ist die nächste	Dove si trova la femata
le plus proche?	Bushaltestelle?	d'autobus più vicina?

Some Swiss rail terminology:

- Intercity: Hourly air-conditioned trains linking major Swiss cities.
- Direct train(*train direct/Schnellzug/treno diretto*) : Express trains serving major and medium-sized cities.
- Regional train (*train régional/Regionalzug/treno regionale*) : Local train making all station stops.

Postal bus

Wherever the trains don't go, the bright yellow postal buses do. They carry mail and passengers over mountain roads to the smallest of hamlets. Their trustworthy drivers have been trained to maneuver on the most fearsome mountain roads in any weather.

Connections between the train and postal buses have been scheduled for convenience. Tickets are sold at the train station, in the bus, and sometimes at the post office.

Boat

All of Switzerland's great lakes are crisscrossed by sizeable passenger boats, often with paddle-wheels. Many have their own restaurants. From Lausanne, the Lake of Geneva (*Lac Léman*) ferries are the fastest way to get to France (9 departures a day for Evian). There are also daily tours around the lake from June to September. Every Sunday in winter, a boat makes the round-trip journey from Lausanne to Vevey, Montreux, Villeneuve, and St.-Gingolphe.

Bus or tram

All Swiss cities have an efficient public transportation network (bus, trolley-bus, or tram). Tickets are available from machines at each stop. You can also buy them from the driver, although the ticket will usually be more expensive. Be sure to hold on to your ticket, as they are frequently checked by roving conductors.

You can also buy books of ten tickets or 24-hour passes (*carte de 24 heures/Tageskarte/abbonamento giornaliero*); ask at major bus stops or newsstands (see also BUDGETING FOR YOUR TRIP).

Taxi

You can always hail a passing taxi, but on rainy days, it might be a better bet to head directly to a cab stand (on major squares or around train stations) or to reserve by phone. Though fares vary from city to city, they are always high. All taxis have a meter and a table listing additional charges for extras such as baggage. Tips are generally included in the price (see TIPPING).

Bicycle

For those who want to get in shape, Switzerland's terrain is rarely flat. You can rent a bicycle (*bicyclette/Velo/bicicletta*) in any major train station (230 throughout the country) and return it (for a 6–12 franc fee) to any other station that accepts bikes (ask in advance!) during opening hours at the baggage counter. You'll find leaflets describing special biking paths at any tourist information office (see also BUDGETING FOR YOUR TRIP).

R

RELIGIOUS SERVICES

Switzerland is almost equally divided between Roman Catholics and Protestants, but they are unevenly spread among the cantons. In big cities, many other religions are represented as well.

The hours of church services (*cultes Gottesdienst/culto*) and mass (*Mess/missa*) are often posted as you enter villages and small towns. Elsewhere, look in the daily papers, at tourist offices, or ask at your hotel reception desk.

What time does the service/mass begin?

A quelle heure est	Wann beginnt der	A che ora è
le culte/la messe?	Gottesdienst/ die Messe?	il culto/la messa?

RESTAURANTS (restaurants/ Restaurants/ristorante)

Switzerland abounds in restaurants of all kinds, from the simplest country tavern to elegant, five-star establishments. In winter, you can thaw out around a fondue in a rustic, wood-paneled *carnotzet* or a cozy *Beizli*, typical Swiss German cafés. The *grotti* of the Ticino, family restaurants

tucked into the most unexpected niches, offer authentic *polenta*. In Geneva, the jolly atmosphere of the brasseries will lift your spirits. In Zurich, former guild houses (*Zunftstube*) now combine history and gastronomy, while in Bern, the wine cellars (*Keller*) bathe you in a medieval atmosphere. Everywhere, in spring and summer, restaurant terraces open onto the lakes, cobblestone squares, or Alpine landscapes.

At high altitudes, fine cuisine marries well with the majestic peaks and views. But instead of an *haute cuisine* feast — the prerogative of the great restaurants in or on the edges of the big cities — you might prefer some local cooking, dominated by hearty sausages and cheese. At lunchtime, if you want to get served quickly, try the daily special (*plat du jour/Tagesteller/piatto del giorno*).

As a general rule, lunch (or "dinner") is served from 11:30am to 2pm and dinner ("supper") from 7 to 9:30pm. You may have a hard time ordering hot dishes outside of these hours, but you can always fall back on a cold snack.

If prices aren't low, they are at least honest, even reasonable, given the high standard of living and the cost of ingredients. Many restaurants also have an adjoining café, where very generous meals are served for remarkably low prices. In popular establishments and cafés, every dish or drink comes to your table with its own check. When you're ready to go, the waiter will add them up and tell you how much you owe. If your waiter's shift ends before you finish your meal, don't be surprised if he comes to collect his portion of the bill. But you can stay at the table as long as you like; another waiter will take over (see also TIPPING).

To help you order...

Waiter/Waitress

Garçon/Mademoiselle	Garçon/Fräulein	Cameriere/Cameriera
Can we have a table, ple	ase?	
Pourrions-nous avoir une table?	Wir hätten gern einen Tisch.	Possiamo avere un tavolo?
The menu, please.		
La carte, s'il vous plaît.	Die Speisekarte, bitte.	Il menu, per favore.

Do you have a special today?

Avez-vous une	Haben Sie einen	Ha il piatto del
assiette du jour?	Tagesteller?	giorno?

I would like...

Je voudrais...

Ich möchte...

Vorrei...

un aperitivo

a pre-dinner un apéritif drink butter du beurre a beer une bière a coffee un café water de l'eau cheese du fromage milk du lait bread du pain fish du poisson potatoes des pommes de terre salad de la salade salt du sel sugar du sucre un thé tea wine du vin

Butter einen Bier einen Kaffee Wasser Käse Milch Brot Fisch Kartoffeln

Salat

Salz

Wein

Zucker

einen Tee

einen Aperitif

del burro una birra un caffè dell'acqua del formaggio del latte del pane del pesce delle patate

dell'insalata del sale dello zucchero un té del vino

Reading the menu in French...

agneau asperges bœuf	lamb asparagus beef	lard macédoine de fruits	bacon fruit salad
canard	duck	médallion	tenderloin
champignons	mushrooms	œufs	eggs
chasse	game	pomme	apple
chevreuil	venison	porc	pork
côte(lette)	chop, cutlet	poulet	chicken
entrecôte	steak	raisins	grapes
fraises	strawberries	saucisse	sausage
gigot(d'agneau)	leg of lamb	saumon (fume)	(smoked) salmon
glace	ice-cream	terrine	paté
jambon	ham	veau	veal

and German...

Apfel	apple	Käse	cheese
Bohnen	beans	Kuchen	cake
Ei(er)	egg(s)	Lammfleisch	lamb
Eis(Glace)	ice	Leber	liver
Ente	duck	Rahm	cream
Erbsen	peas	Reis	rice
Erdbeeren	strawberries	Rindfleisch	beef
Forelle	trout	Rösti	potatoes
Fruchtsalat	fruit salad	Schinken	ham
Geflügel	poultry	Schweinefleisch	pork
Gemüse	grilled sliced	Spargel	asparagus
	vegetables	Speck	bacon
grüne Bohnen	green beans	Teigwaren	noodles
Huhn	chicken	Weinerli	Vienna sausage
Kalbfleisch	veal	Wurst	sausage
and Italian			
agnello	lamb	manzo	beef
fagioli	beans	polenta	boiled cornmeal
fagiolini	green beans	pollo	chicken
filetto	filet (of beef)	pono prosciutto	ham
formaggio	cheese	riso	rice
fragole	strawberries	spinaci	spinach
frutta	fruit	trota	trout
funghi	mushrooms	uovo(a)	egg(s)
gelato	ice-cream	verdura	vegetables
insalata	salad	vitello	vegetables
mound	Jaiau	rucuo	, cai

TELEPHONE (téléphone/Telefon/telefono)

T

Swisscom is responsible for telecommunications, but it no longer has a monopoly in the country. Phone booths, which you see everywhere (including in most post offices) are kept clean and in good working order; all of them have instructions in four languages. You can use them for direct international calls. To use the majority of public phones you will

need a *Taxcard*, a magnetic calling card available at post offices and newsstands. You can also use Visa, Eurocard, or American Express.

TIME ZONES

Like most of the Continent, Switzerland is on Central European Time, which is Greenwich Mean Time +1 hour. In summer, Daylight Savings Time is applied at the same dates as in neighboring countries.

TIPPING (pourboires/Trinkgeld /mancia)

Tips are generally included in the bill, but if you feel you have received exceptional service, you may round off the total. Porters will expect a coin. Taxi drivers also get a tip, usually around ten percent.

TOILETS

Everywhere in Switzerland, public toilets are clean and easily accessible. Instead of conventional symbols or inscriptions like *Toiletten*, *gabinetti* or *WC*, they are marked *Damen*, *Frauen* (in Swiss German) or *signore*, *donne* (in the Ticino) for women, and *Herren*, *Männer*, or *signori*, *uomini*, for men.

Where are the bathrooms?

Où sont les toilettes? Wo sind die Toiletten? Dove sono i gabinetti?

TOURIST INFORMATION OFFICES

In major cities throughout the world, you will find a Swiss National Tourist Office to provide you with all the information you need in planning your trip.

Australia/New Zealand: Switzerland Tourism, c/o Swissair, 33 Pitt Street, Level 8, NSW 2000 Sidney; Tel. (02) 9231-3744; e-mail swissair@tiasnet.com.au

Canada: Switzerland Tourism, 926 The East Mall, Etobicoke (Toronto), Ontario M9B 6K1. Tel. (416) 695-2090; fax (416) 695-2774; e-mail stnewyork@switzerlandtourism.com

UK and Ireland: Switzerland Tourism, Swiss Centre, Swiss Court, GB-London W1V 8EE; Tel. (171) 734-1921; e-mail stlondon@switzerlandvacation.ch

US: Switzerland Tourism Los Angeles, 222 North Sepulveda Boulevard, Suite 1570, El Segundo, CA 90245; Tel. (310) 335-0121; e-mail stnewyork@switzerlandtourism.com

In Switzerland itself, the head branch of the National Tourist Office is at Tödistrasse 7, CH-8027 Zurich; Tel. (01) 288-1205; website www.switzerlandvacation.ch

Every region, city, and resort has its own tourist office (office de tourisme/Verkehrsburo ou Verkehrsverein/Ente per il Turismo), with a supply of free brochures, lists of hotels, and maps; the information is generally local. Below are the addresses of some regional offices:

Basel	Schifflände 5, 4001 Basel; Tel. (061) 268-6868; e-mail office@baseltourismus.ch
Bellinzona	Via Lugano 12, 1441, CP, 6501 Bellinzona; Tel. (091) 825-7056; e-mail ett@www.tourism-ticino.ch
Bern	Im Bahnhof, Postfach, 3001 Bern; Tel. (031) 328-1228; e-mail info@smit.ch
Chur	Alexanderstrasse 24, 7001 Chur; Tel. (081) 254-2424, e-mail: contact@graubuenden.ch
Fribourg	Route de la Glàne 107, 1701 Fribourg; Tel. (026) 402-5644; e-mail info.tourisme@pays-de-fribourg.ch
Geneva	Route de l'Aéroport 10, 1215 Genève 15; Tel. (022) 929-7011; e-mail info@geneve-tourisme.ch
Interlaken	Jungfraustrasse 38, 3800 Interlaken; Tel. (033) 823-0303; e-mail Bernroberland@hallweb.ch
Lausanne	Avenue d'Ouchy 60, 100 Lausanne 6 Ouchy; Tel. (021) 613-2626; e-mail Lake.geneva.reg@fastnet.ch
Lucerne	Alpenstrasse 1, 6002 Luzern; Tel. (041) 418-4080; e-mail information.cent@centralswitzerland.ch
Neuchâtel	Hôtel des Postes, 2001 Neuchâtel; Tel. (032) 889-6890; e-mail euchatel@tourisme.etatne.ch
Saint-Gall	Bahnhofplatz 1a, 9001 St. Gallen; Tel. (071) 227-3737; e-mail info@ostschweiz-i.ch
Saignelégier	Rue de Gruyière 1; Tel. (032) 952-1952

U

Sion	Rue Pré-Fleuri 6, 1951 Sion; Tel. (027) 322-3161; e-mail uvt@wallis.ch
Zurich	Bahnhofbrücke 1, CH-8023 Zürich; Tel. (01) 215-4099; e-mail information@zurichtourism.ch

Where is the tourist office?

Où est l'office	Wo ist das	Dov'è l'ufficio
du tourisme?	Verkehrsbüro?	turistico?

USEFUL EXPRESSIONS

Good morning Good evening Good night Goodbye yes/no please thank you when/where how yesterday today tomorrow day/wask	bonjour bonsoir bonne nuit au revoir oui/non s'il vous plaît merci où/quand comment hier aujourd'hui demain	Guten Tag Guten Abend ute Nacht Auf Wiedersehen ja/nein bitte danke wo/wann wie gestern heute morgen Tag Wighta	buongiorno buona sera buona notte arrivederci sì/no per favore grazie dove/quando come ieri oggi domani
day/week	jour/semaine	Tag/Woche	giorno/settimana
month/year	mois/année	Monat/Jahr	mese/anno
left/right	gauche/droite	links/rechts	sinistra/destra
high/low	en haut/en bas	oben/unten	sopra/sotto
good/bad	bon/mauvais	gut/schlecht	buono/cattivo
big/small	grand/petit	gross/klein	grande/piccolo
cold/hot	chaud/froid	heiss/kalt	caldo/freddo
old/new	vieux/neuf	alt/neu	vecchio/nuovo
open/closed	ouvert/fermé	offen/geschlossen	aperto/chiuso
free/occupied	libre/occupé	frei/besetzt	libero/occupato
early/late	tôt/tard	früh/spät	presto/tardi
easy/hard	facile/difficile	einfach/schwierig	facile/difficile

Help me, please.

Aidez-moi, s'il vous plaît. Helfen Sie mir, bitte. Mi aiuti, per favore.

What does that mean?

Qu'est-ce que cela	Was bedeutet Das?	Cosa significa questo?
signifie?		

I don't understand.

Je ne comprends pas. Ich verstehe nicht. Non capisco.

Could you speak more slowly?

Pourriez-vous	Könnten Sie	Potrebbe parlare
parler plus lentement?	langsamer sprechen?	più lentamente?

Thank you very much.

Merci beaucoup.	Danke vielmals.	Tante grazie.

WEIGHTS and MEASURES

Switzerland uses the metric system.

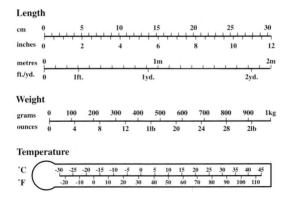

ABOUT BERLITZ

In 1878 Professor Maximilian Berlitz had a revolutionary idea about making language learning accessible and enjoyable. One hundred and twenty years later these same principles are still successfully at work.

For language instruction, translation and interpretation services, cross-cultural training, study abroad programs, and an array of publishing products and additional services, visit any one of our more than 350 Berlitz Centers in over 40 countries.

Please consult your local telephone directory for the Berlitz Center nearest you or visit our web site at http://www.berlitz.com.

Helping the World Communicate